HOW TO CREATE
PAINT
EFFECTS

Charles Hemming

**CHARTWELL
BOOKS, INC.**

A QUINTET BOOK

ISBN: 0–7858–0548–6

This book was designed and produced by
Quintet Publishing Limited

Art Director: Nigel Osbourne
Senior Editor: Patricia Webster
Assistant Editor: Jane Laing
Designer: Ian Hunt
Illustrator: Richard Phipps
Photographers: John Heseltine, Ian Howes, Jon Wyand
Jacket Design: Nik Morley

Typeset in Great Britain by
Central Southern Typesetters, Eastbourne

Produced in Australia by Griffin Colour

Published by Chartwell Books
A Division of Book Sales, Inc.
P.O. Box 7100
Edison, New Jersey 08818-7100

CONTENTS

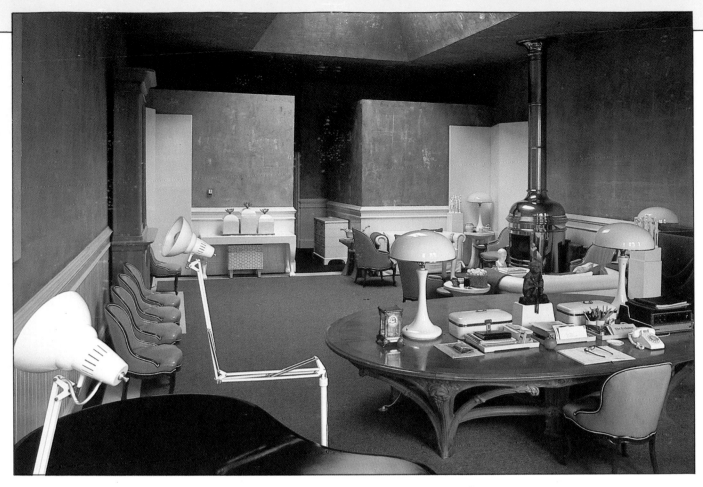

COLOR WASHING

Color washing means applying a coat of thinned, and sometimes translucent, paint over a white or colored ground. This can be done with oil- or water-based paint but the term is frequently associated with distempering. Most people think of distemper as a powdery, off-white wash applied to old wooden houses or the lower walls of tenement blocks. In fact, it is a highly attractive and versatile medium that is very easy to use, offering effects varying from glowing translucence to a chunky, rugged texture that can enhance what seemed to be a hopelessly uneven wall. Apply it thickly on a rough surface — say in ocher — and it can give a texture reminiscent of oatmeal; applied thinly over the same type of surface it can give a shimmer like that on a lighted cave wall. You can lend a warm glow to a cold, north-lit room by giving it a wash of rose madder, yellow ocher or pale red-gold — all colors that might overwhelm a room if applied neat .

■ **Materials** Distemper has the asset of being very cheap; it is probably the cheapest of all paint finishes. As a result of this, many shops find it unprofitable to market and therefore don't stock it. Fortunately, however, distemper is very easy to make. All you need is whiting, (which is composed largely of crushed chalk that has been powdered, washed and dried); glue size; a tinting agent such as artists' acrylic, powder color, artists' gouache or universal stainers; two buckets and access to plenty of water. Make the distemper by breaking up the whiting into small lumps, putting it in a clean bucket, pouring cold water over it and leaving it to soak for 30 minutes. Then pour off any excess water and beat the solution to a smooth, thick batter. Distemper lightens as it dries, so you should test the color first, before adding the size. Dissolve the stainer separately in cold water, because if you add it dry you'll get streaks of undissolved pigment; then stir it gradually into the whiting. Take it slowly — you can always add more pigment but you can't subtract it. Test the color on a piece of thick paper and dry it in the sun or before

a fire. Bear in mind that when you add the size, the color will darken slightly. When you have the color you want, add the size. This, too, should be mixed separately, according to the manufacturers' instructions. Use hot water and blend the size solution with the whiting while still warm. If by chance you've mixed the size and haven't been able to add it before it has set, heat it over a pan of water on the stove.

Adding size to distemper is a delicate affair because too much will make the distemper flake and too little will make the mixture too powdery to adhere to the wall when it dries. The safest rule of thumb is that the distemper/size mixture should have the consistency of standard latex paint, when it is to be used as a basic ground coat. For a wash coat, thin it to a milky consistency with water. In either case, only mix about as much as you can use in a couple of days; otherwise it will start to go off.

■ **Application** You can apply distemper over any sound, flat or gently undulating, dry, clean paint surface except old distemper, which will pick up on the brush and produce a patchy ground. You should wash off any old distemper thoroughly and then coat the surface

with pure size or claircolle. Claircolle is a mixture of size and whiting which gives a white, uniform base ground for the first coat of tinted distemper.

Like most water-based paints, distemper dries very quickly and this is the main problem with applying it. To lengthen the drying time, some English theatrical scene-painters add treacle to it, about one dessert-spoonful to 1¾pt (1 liter), but you can use glycerine in the same amount if you can't get treacle. Close all the doors and windows and apply the distemper liberally and quickly, starting with the window side of the room and working inward. Direct your laying-off brush strokes toward the light; if you miss a portion of wall, it's better to touch this up with a sponge, as brush strokes are difficult to blend in once the surrounding area has started to dry. When you've finished, try to get as much air circulating in the room as possible by opening all the doors and windows. If you've just put on a ground coat, preparatory to a final wash coat, leave it to dry out for at least 24 hours.

OTHER METHODS OF COLOR WASHING

The method that comes closest to easel oil-painting is applying a wash of flat-oil, mixed in a proportion of 1:8 with mineral spirits, over an egg-shell finish. This gives an overall, even, nearly matt, translucent quality to the finish and great depth to the color. You have to work reasonably quickly, as the mineral spirits acts as a drying agent, but this method usually avoids any brush marks or hard edges.

With latex, you can obtain a very subtle 'distressed' texture by thinning the paint with water and using the brush strokes in a criss-cross 'hatching'; this transforms the difficulty of latex finishes into an asset. You then over-glaze again on top of the distressed effect so that the ragged areas of brushwork show through. The most translucent of all washes consists of pure pigment and water, which needs to be mixed with a small amount of latex to give it some body ; use about two table-spoonful of paint per 1¾pt (1 liter) of water, and use artists' gouache as the main tinting medium. Gouache pigments are very powerful, so add a small amount first and more if necessary. If you are adding tinting pigment to flat-oil wash thinned with

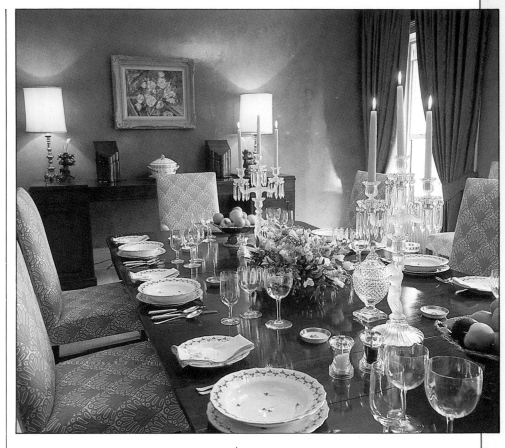

mineral spirits, use artists' oils for tinting. In either case, always mix the tinting agent thoroughly in its appropriate solution first — mineral spirits for oils, water for gouache — before adding it to the thinned paint, as a speck of unmixed pigment can leave a long streak right across a wall. In all cases except flat-oil, washes should be applied to a flat, latex-painted surface. The surface should be grease-free, as wash will simply run off greasy patches. These can be found and removed by wiping the surface with a water-vinegar solution after washing it and then rinsing it thoroughly.

■ **Application** If you decide to apply the distressed effect with latex as mentioned above, apply the color wash liberally and loosely, brushing in all directions and either leaving areas of the base coat unbrushed or covering them only very lightly. Allow this application to dry for 24 hours, and then apply the second wash coat. Put this on thinly and evenly all over the surface, so that the distressed patches show through, their color being enriched by this second coat, while the undistressed areas will appear softer. If any wash starts to run, just work it in with a sponge or brush it vigorously. At the half-way stage the general effect can

Above A soft, moss-green color wash with a gloss varnish finish. Gloss paint is highly unsuitable for such a wall area and silk finishes do not possess the element of depth. Varnish offers not only protection but also a translucent glow that retains the color beneath it.

appear rather bedraggled, as if the wall were a half-molted snake skin, but don't get depressed — it should look like that. The third and fourth wash coats will merge in, and if you have chosen different colors for them, they will produce a series of veils of shifting, translucent color with a luminosity that can't be achieved with any other method. The distressed areas will be of more intense color, the other areas of a softer effect with an element of depth.

If you have not distressed the surface and apply a number of even washes you will, in effect, be applying a series of color filters to the wall, rather like translucent sheets of misty, colored glass, one on top of the next.

It's best to leave color-washed walls in their matt, rather unfinished-looking state. This is because when outlines of woodwork, such as doors and baseboards, have been sharpened up the broken color walls look more intentional and their panache and beauty are accentuated by the contrast. You can apply broken color to woodwork but it is less advisable. The reasons for this are hard to pinpoint when talking about hypothetical rooms but suffice

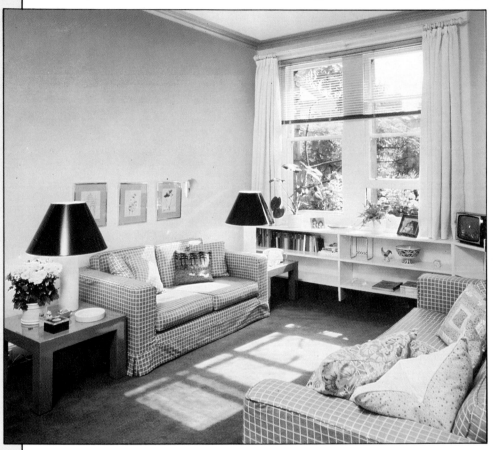

Above *Shading offers a delicacy and ambiguity of light to wall and ceiling areas of almost any size. Depending on whether the room is used throughout the day or only at certain times, the color shift can be used to achieve a dramatic effect in strong sunlight or bright artificial light or gentler effects in softer light. Remember that natural light shouldn't contradict the direction of the shading, or you'll lose the transition altogether.*

it to say that walls and woodwork both given the same treatment lose form and strength; at best they look cluttered and shapeless — at worst they have the vulgarity of a comic-opera palace.

If you want to varnish broken color, use a matt polyurethane varnish; it will still give a slight sheen but less than any other type.

SHADING

This involves blending transitions of color from light to dark across a surface. It's a process that can most easily be done by two people, and it can be used to adjust not only the light effects but the proportions of a room very effectively. A very high ceiling can be visually lowered by beginning with a pale tone at the bottom of the walls, gradually darkening toward the top and finishing the ceiling in the deepest color. The reverse effect is achieved by reversing the process. Walls can be "softened" by giving them a pale tone in the center and deepening it out toward the edges. Shading can be done with tones of the same color — say, pale magnolia shading to golden buttermilk — or with harmonizing tones of different colors; that is, different colors of equal brightness. If you're using different colors, you must be careful in your choice and in arranging the harmonizing sequence. Be careful that, if you place two complementaries together and blend them, you don't get a murky gray at the transition point. If you have pale sky-blue at one end and pale pink at the other you'll get gray in the middle. So look at the color wheel for intermediary tones, such as lilac or mauve, and blend those between the blue and the pink. Don't over-do shifts of color. The danger with this technique is ending up with something that looks like a stage back-drop, without footlights to quell it or a curtain to blot it out. Fire-red blending into violet and deep blue may evoke a dazzling sunset, but it can also look disturbingly like the burning of Atlanta. Shading works best with light pastels.

SHADING WITH OIL-BASED PAINT

■ **Materials** As with easel-painting, soft gradations of color are most easily achieved with oil-based paint; flat-oil is therefore the best choice for this technique. However, manufacturers tend to supply it only through specialist outlets in a much-reduced color range (partly, one suspects, because it's so versatile that it reveals the shortcomings of all the other so-called convenience paints; for example, the thick, slimy, non-drip types that can't be mixed, can't be thinned, can't be glazed and can't therefore be seen as convenient once you've worked with truly versatile paint). A good substitute for the excellent but difficult-to-get flat-oils is undercoat, which can be bought anywhere. For shading, buy a large can in the palest of the toning colors or white

and just tint it yourself. Dissolve the pigment — artists' oils are the best — in a little mineral spirits and then mix the solution into the paint gradually, stirring carefully and thoroughly to avoid streaking. Add pigments little by little — you'll be surprised how strong they are and how quickly they change the color of undercoat — and thin the undercoat with mineral spirits, as this will help blending. *Don't* thin it more than 1:3 parts mineral spirits to paint, or the covering power will be inadequate.

■ **Tools** Ordinary paint brushes are necessary for the application of undercoat, base-coat and the initial

or rough blending of the top coat, but the blending itself should be done with stippling brushes. These are rather expensive, though; large sponges are a good substitute and can be strongly recommended.

■ **Ground coats** If you are using flat-oil as a ground, apply an undercoat first. If you are using undercoat as a substitute for the flat-oil, apply an untinted undercoat full-strength and then the lightest shade of the tinted undercoat that you've mixed. Apply as many coats of this as is necessary to get a solid finish. Whether using flat-oil or undercoat as a ground, the last coat can be thinned with a 1:2

Above *A softly sponged finish. There is a harmony between the firmly plush quality of the furnishing, the crispness of glass and the quiet solidity of stonework that is created by the peach-like texture of the walls.*

mixture of linseed oil and mineral spirits to give the paint enough gloss when dry to aid manipulation of the shading coat over it. If there is a big variation between the darkest and lightest of the shading colors roughly blend the last ground coat, too, to stop the paler parts of it showing through the top coats.

■ **Top-coat tones** About three shades of color are usually adequate for a wall in an average-sized room. Mix the largest and darkest first and then the middle tone or tones. For a big wall or a very tall room (not quite the same thing) you may need five shades; mix the lightest and middle tone first, then the darkest. The more tones you have, the more they need managing, and while you want them to stay workable and need them thin for blending, the more mineral spirits you add, the quicker they dry. So, if you have a number of tones over a large area, add about one part of linseed oil to eight parts of paint to slow the drying. If there are any small areas that have been missed, which you want to slow down, use the same proportion of oil glaze.

■ **Application** It's useful to have a guide-line on the wall approximately where you intend the areas of blending to occur. Do this with chalk: a length of twine rolled in chalk is very effective, and light blue chalk is best because it vanishes in paint. Using a spirit-level, measure a series of equal spaces along the top of the wall and a similar number of equal spaces at the sides. Attach a weight to the bottom of the twine, then suspend this from each mark along the top of the wall in turn, 'snapping' the twine taut against the wall; this will leave a vertical chalk line. Complete the grid with horizontal lines, either with a spirit-level or with the help of someone else to hold the other end of the twine, 'snapping off' against the wall as before. Decide in which grid squares you want the transitions of shade and mark them with chalk.

Always begin shading with the palest color and work steadily toward the darkest. Brush the lighter color into the next as evenly as possible with the ordinary brush, moving like this right across the wall. If you can, change to a clean brush about half-way across, to avoid carrying too much light color into the darker. Then go over the roughly blended areas with a stippling brush or sponge. The blending should not be done wholly with the stippler

because the transition will be too abrupt; again, either change to another stippler half-way across or, if you can't rise to two stipplers, clean the brush. Ideally, it's good to have one person begin stippling while the other person works ahead putting on the color with the ordinary brushes. But always make sure that the same person stipples because no two people's techniques are the same; if you alternate, the result will look uncoordinated.

SHADING WITH WATER-BASED PAINT

It isn't really advisable to attempt large-scale shading with water-based paint. The water tension causes bands of color to show like tide-marks and the paint dries by evaporation rather than by reaction — as it does in the case of oil. If you are going to attempt shading with latex, a coat of oil-based primer is useful as this makes the surface less porous; a silk-finish ground coat is also advisable, as it is less absorbent. If you are going to attempt shading on lining paper, soak it thoroughly. It must be very securely stuck to the wall, and even so you can expect it to blister while you are painting, as it will be so wet, but it should shrink back. In any event, when using latex on a wall or lining paper, keep the atmosphere as damp as possible. Put wet cloths on the floor over plastic sheets if you can, shut the doors and windows and dampen the wall. When you paint, apply narrow bands of color, starting with the lightest and adding more of the darker tones as you go, stippling each blend immediately and moving on to the next tone. It really is an asset to have two people working on this together, one stippling with a stippling brush or sponge while the other moves ahead, applying and doing the initial blending. Latexes are more successful for shading small areas than large ones; oil-based paint is really the best medium for this technique.

SPONGING

Of all broken color techniques, sponging is almost certainly the easiest and perhaps the most fun. It's very relaxing because there are so many things you don't have to worry about, like drying times, even glazes, keeping a wet edge going, keeping the environment damp or laying off

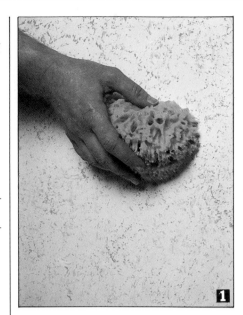

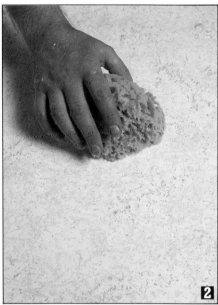

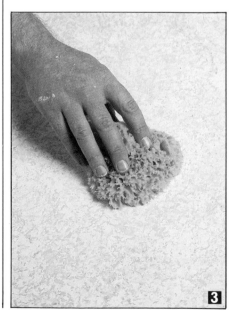

Sponging method

1. Always begin with the darkest color, widely spaced, to give depth. Here, a watery bottle-green is used.
2. A pale beige-green is added, more closely spaced.
3. A pale creamy-gold over coffee brings the surface upward visually.
4. A light, random softening is given to the entire surface.
5. The result is a scattered, floating pattern you can look "into" not "onto".

toward the light. You can forget the lot and dab away to your heart's content. As a bonus, if you use oil-based paint you can wipe it off with a rag soaked in mineral spirits, should the result be not quite what you wanted.

There are a variety of possible effects with this technique as there are three variables: the glaze medium, which can be translucent, opaque, matt or shiny; the sponge texture; and the choice of colors, which may often be a combination of three or four.

The variety of color depends on what you want. There are fresh, sharp combinations, such as black over emerald, emerald over tangerine, tangerine over white; there are various combinations of tones from the same color family, such as coffee over beige and caramel over that, or dusty blue, duck-egg blue and sky-blue; and highly sophisticated variants like electric blue over emerald or scarlet. If you use latex paint you can gain delicate, clouded combinations; for example, misty mauve and forest green sponged over sage, or dusty blue and pale olive clouded over pale lilac and dove gray. Whatever you do, remember that sponging in two colors works best with the lighter color on top, as this gives depth to the effect.

■ **Materials** Oil-based paints give a crisper texture to sponging, resembling densely crystalline stone; latexes give softer, cloudier mottles; if you want a translucent, marble-like finish, use an oil glaze. The best sponges to use are genuine marine sponges, because their texture is so varied, although ordinary cellular sponges are quite adequate — just watch out for their flat surface. Make sure you keep twisting them about with turns of the wrist between dabs to avoid getting any marking with the edge of the flat face that would make the pattern look too regular. Another way to avoid hard lines is to make an irregular tear through the sponge with the aid of a knife. Massage sponges have some interesting effects to offer and can be as stimulating with paint as they can be on the skin.

Besides sponges, you need a paint tray — the slanting type you'd use with a roller, with a paint reservoir at one end — clean rags, lint-free and undyed, and cartridge or lining paper on board.

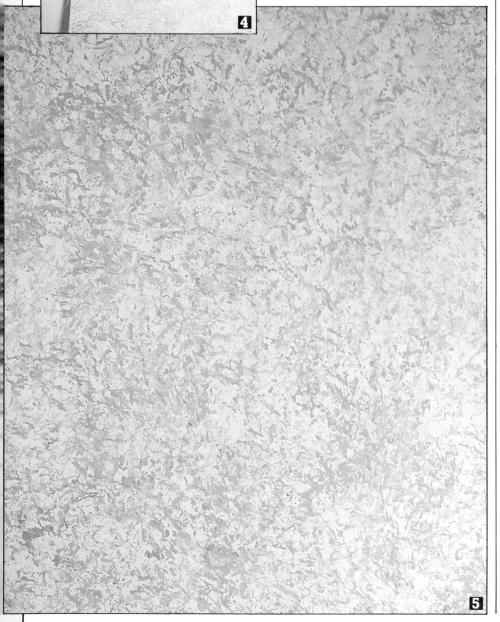

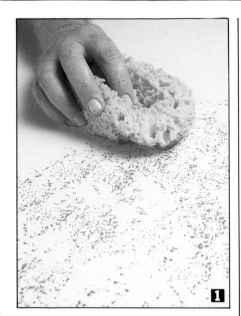

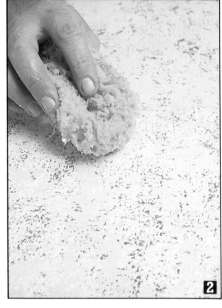

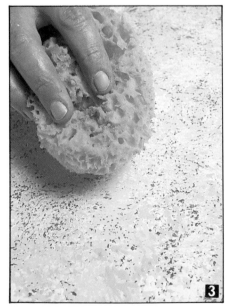

Sponging methods: conventional

1 An Indian red mottle is sponged over a pale Naples yellow ground with a soft marine sponge.
2 A loose magnolia stipple is dabbed over this, to give a sense of depth.
3 A dove gray is dabbed in over the other colors, giving a stone-like or ceramic quality.
4 Sponging frequently evokes the qualities of other surfaces, from unpolished rock to felt, leather or cork. Here, the finish is similar to that of granite.

Reductive

5 The sponge, coated in thinner, can be used to absorb paint, exposing a different color below; this technique gives a grittier, harder, drier finish.

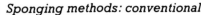

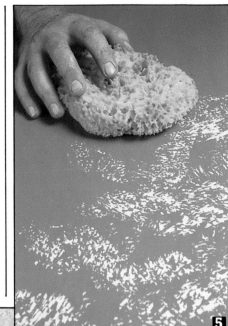

■ <u>Application</u> If you use a real marine sponge — always preferable — it's best to soak it in mineral spirits first to soften it for use with oil-based paint, or in water if you're using latex. Let it expand again to its full size and then allow it to dry before using. Dab the sponge *lightly* into the paint tray and test it out on thick paper. Do this until you get a well-defined impression; then use the sponge on the surface. Test it on the paper each time before you apply it. This may sound laborious but it isn't: it just needs one or two dabs to check there's no excess, and then straight to the surface. If you are applying a color that is to have another color sponged over it, keep the prints even and well-spaced, wait for them to dry and then fill in between and over them with the other color. Try to avoid enervating repetition of pattern, by altering the position of the sponge in your hand. Wash the sponge regularly in mineral spirits or water but always wring it out thoroughly or you'll risk diluting the glaze or paint too much.

You can also produce a foggy or cloudy ground by sponging, which is an effect ideally achieved by two people. One lays on the base color and the other follows, sponging another color into it. When this dries, you can sponge on the top effects.

Cloudy effects made by sponging varnish over latex can be matt or gloss, unlike those achieved with color wash. Sponging varnish on top of the sharper, oil-based paints creates a surface like exotic polished stone, particularly suited to furniture.

STIPPLING

Stippling is the first cousin of sponging; it is really the same process, only using a sharper implement — the stippling brush. This is a large, flat-faced, soft-bristled brush which is dabbed on wet glaze and lifts just enough of it off for the background color to show through. The result is a fine, mottled texture sometimes compared to orange-peel. However, stippling brushes are extremely expensive and it is often advisable to find an alternative if you don't think you'll be using one often enough to justify the cost. If you are going to stipple a small area like a table, the best substitute is a soft shoe-brush; but if you intend to stipple, say, a whole stairwell wall — which, even in a two-

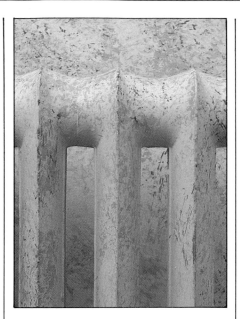

Above *Immovable or intrusive objects such as radiators can be camouflaged into an interior by careful sponging.*

Sponging Furniture

Either the very soft finishes offered by latexes or the very sharp, vividly colored mottles created with oils work best on furniture. It's advisable to be definite. Light, leggy furniture shouldn't be sponged except in oils, because soft effects just won't show up on it. Large furnishings — such as chests of drawers — work well with soft, marbled effects provided that they are protected with varnish, while table-tops and desks need a sharper, denser mottle, such as porphyry. The contrast achieved by sponging opening panels — such as drawers and cupboard fronts — while leaving the rest of the chest or cupboard unmottled, creates an interesting effect.

storey house, is quite a large area — you can get very tired with so small a tool and fatigue can make you careless, so that the stippling can become gashing and smearing. On a very large area, a sharp-bristled broom can be very effective. The long handle can be useful if you have to make a long reach; otherwise, remove it. Cut the broom bristles down with a saw or use a broom that's already worn down. You can stand back and use the broom from hip-height in a comfortable manner, you can reach a ceiling with ease and, if you are half-way up a ladder, you can just as easily reach down; it saves you climbing back and forth.

For very small areas — smaller than those where you'd happily use a shoe-brush — use a painter's dusting brush or a soft-bristled hairbrush. On an area of textured paint, large or small, you can use a rubber-tipped stippling brush, which is cheaper than the standard stippler but gives a rather coarse effect. All these tools produce a different texture but they all have one thing in common: a flat bristle surface, which is essential. Stippling won't work without it.

You don't have to use brushes at all. Alternatives include the attractive marine sponge with its softer stipple; a cellular sponge cut down the middle with its crisp, granular markings — the sponge should be rotated from side to side as you work; clean, undyed, screwed-up rags — similar to the method of rag-rolling; and even rollers.

In fact, rollers are the quickest method of stippling, but the hardest to control. If you use a roller, use the very coarsest you can get. Real or synthetic mohair rollers are the best; wool ones are good, too, but the smooth polystyrene ones won't work for stippling; they'll spread glaze all about in swirls like those you see if you close your eyes when you've got the 'flu. These tools all vary in finish but none gives the open, sharp texture of brush stippling.

The paint types for stippling can be just as varied as the tools. You can try stippling with matt paint over a shiny surface, or with low-luster over matt. Most traditional treatments consist of stippling a transparent or semi-transparent glaze over a white or light-colored ground. The clean, solid glaze color is broken by the tiny fleckings of the stippler to reveal specks of the ground color underneath. For example, a soft orange-gold over magnolia gives the velvet appearance of a lightly

Top Linear moldings in unbroken color frame stippled flat areas in this pleasing window panel.

Above Fine stippling over an entire wall is time-consuming but creates an interesting visual texture.

Stippling Table Tops

Stippling can be applied to give a loose, overall finish as on walls, or can form quite precise patterning. The only danger lies in applying too many colors. The geometric maze patterns used in formal gardens work well on table-tops. The variety of stippling textures augments the color variation between the areas, which can be divided by masking tape to prevent the stipple "straying".

powdered cheek. Salmon stippled over white looks like peach skin, coffee over cream like natural suede, electric blue over dove gray like shark-skin. Multicolored finishes give you the chance of blending a shifting mottle with no line of demarcation and with the variety of a cloudscape. It's quite possible to stipple either walls or woodwork but it's not a good idea to do both because, like sponging, stippling needs a contrasting finish to set it off. Stippling is suitable for use on furniture, but it is advisable to limit the number of colors, and to display the item against a plain surface.

■ **Materials** After applying your ground color with an ordinary brush, and selecting your stippling tool, you need pigment for tinting, a thinning agent, a couple of ordinary, flat paint brushes for applying the glaze and plenty of clean rags or paper for wiping the stippler and mopping up.

■ **Application** Stippling is very easy and simple, but more convenient and quicker with two people. Make sure that the ground color is dry, and then apply the glaze tone with an ordinary brush in a vertical band about 2ft (60cm) wide. Ideally, once this is applied, a second person should begin stippling the glaze while the first begins the second band. The stippler should leave about 3–6in (7.5–15cm) unstippled on the right-hand edge (when working from left to right); when the next band of glaze has been applied, go over the join and keep moving into the new band of glaze. Laying on and stippling take about the same time, so it is possible

to work without one person leaving the other behind. The glaze should be brushed out to a fine, even film and the stippling done by pressing the tool flat to the surface with a gentle but firm, decisive, dabbing motion — taking care to avoid skidding. Only one person should do the stippling, in order to achieve uniformity of touch.

Eventually, the stippling tool will get overloaded with glaze and should be cleaned by wiping its surface in mineral spirits. If an area is missed, it's easier to brush glaze onto the stippling tool's bristles and dab that on than to try to put more glaze on with a brush and then stipple it off. If you accidentally put two glaze coats on the same spot you can usually reduce them with a clean stipple tool; if the glaze is very stubborn and partly dry, moisten the area with mineral spirits and use a clean stippler.

If you use a roller, only one person should do the job. You have to keep the pressure even and avoid skidding. Otherwise, roller stippling is so quick it takes less time to stipple the glaze off than to put it on. You must be sure to keep the roller clean, though, by rolling it regularly on clean paper to take off any glaze build-up.

When you've finished, wash the tools in mineral spirits; rollers and sponges should be rubbed over paper and squeezed out in this solvent.

■ **Note:** *Be very careful if you are discarding rags on which solvent, paint and glaze have collected during cleaning. Let them dry out thoroughly first. Damp, screwed-up rags, steeped in this mixture of chemicals, are highly inflammable and if put into the black plastic sacks widely used for refuse collection can combust spontaneously, especially in warm sun. They are, in effect, potential gasoline bombs.*

DRAGGING AND COMBING

Dragging and combing have much to do with the representational technique of simulating wood grain, but dragging is a freer use of the basic graining technique and combing is a simplified stylization of it.

Dragging is basically dragging or coasting a dry brush over a wet glaze. Decorators most commonly use the brush vertically to achieve a

series of fine, variably spaced lines, which reveal the base color and leave the surface texture not unlike woven cotton, with pronounced vertical strands. The addition of a second glaze coat means that another series of dragged lines can be applied either vertically or horizontally, and a second set of verticals in a slightly different color can give the surface the appearance of raw silk. Verticals and horizontals together resemble a colored weave of heavy gauze; while applying the glaze in different directions, but dragging vertically, can achieve a shot-silk effect as the light strikes the glaze particles at different angles. Dragging usually creates a general effect of something other than paint.

The prime difference between combing and dragging is one of fineness. Dragging has a far softer, gentler appearance than combing, which is broader, starker and rather more dramatic in pattern. Both techniques can be used on walls but combing is more suitable than dragging for floors because of its heavier effect. Dragging is more suitable for woodwork, including furniture, as combing can look harsh — as if the grain has suffered some strange, woody rigor mortis.

Combing is very much what it sounds like: running a comb over wet glaze. This technique differs from dragging not only in the final finish but also in the range of tools that are suitable for it. Any hard,

Above *Dragging gives a clean, subtly aged quality, where other broken color might have become disjointed, and lends an air of elegant restraint to the potentially busy designs of carpet and furniture.*

Above *This finely dragged interior has the appearance of being hung with dull silk.*

Right *A flat-faced brush gives close, fine lines similar to the texture of woven fabric.*

Far right *A soft brush gives a broader, looser finish closer to the look of wood grain.*

comb-like object will do, from chipped stiff linoleum to a fine hair comb. Whatever tool you choose, the stroke is firm and continuous and the lines never have the feather-like quality given by a brush. At their very finest, using a hair comb, the lines resemble the old silver-point engraving technique, but they are always forthright and without the organic quality of brush dragging. As a result, the colors, too, can be starker. With the softness of dragging, very dramatic contrasts like lampblack on scarlet do not work because the fineness of stroke prevents the strong colors from showing clearly at a distance of more than about 1ft (30cm) and the effect can be brown and muddy. Dragging works well in pastels, such as sky-blue over soft emeralds, or earth colors, such as Indian red over ocher.

The prime difficulty many people encounter with dragging is keeping the hand steady to make a drag stroke as straight as possible. Often, the problem is trying too hard: if you hold the brush very tightly — which means it shakes — and then press it against the surface too hard, the bristles have too much spring in them and the whole effect soon has an uncontrollable wobble. The best way to hold the brush is by the haft, resting the handle across your hand as you would the shaft of a pen. Remaining relatively loose-wristed, simply rest the bristles on the surface and in one stroke coast the brush down the wall. Many people doubt their ability to make such a straight vertical stroke on a wall. There are two things you can do to help yourself. Either use a plumb-line suspended from the ceiling, about 1in (2.5cm) from the wall, and follow it down; or use a straight-edged board, with nails in it to hold it off the wall surface, and run the edge of your hand or the corner of the brush haft along it as you make the stroke. You can perform horizontal strokes in the same way, keeping the board true with a spirit-level. If for some reason there is no way you can make a single downward stroke, stop the downward motion between waist-level and the baseboard, as any unevenness will then be well below eye level; then brush upward to meet your first stroke, feathering the join lightly. Stagger the level of these joins, so that you don't get a noticeable ripple effect of joins along the wall.

As both dragging and combing

are suitable for walls, this method of working is suitable for both. For one-way dragging, however, you should ensure that the walls are smooth and even because, unlike many other broken color techniques, the use of vertical lines stresses any irregularities.

■ **Tools and materials** As with so many other specialist tools, dragging brushes are expensive and, unless you expect to use them often, it is reasonable to seek an alternative. Perhaps the best is a large, wide, paper-hanging brush. Jamb dusters are also very effective.

Combing is less demanding as far as tools are concerned. Graining combs are the official tool, of course, and although these are not nearly so expensive as dragging brushes, alternatives are much easier to come by and a lot of fun. Stiff hair combs, especially those with big plastic or steel teeth, are very effective, and you can bend them or break the teeth to give variety of stroke. Any number of comb-shaped variations can be invented by cutting V-shaped slots out of linoleum or plastic, which are also easy to clean.

Dragging and combing are usually easiest and most successful with an oil glaze over flat-oil paint, undercoat or egg-shell. This is because the glaze dries more slowly over their non-absorbent surfaces and because their tough skin stands up to the teeth of combs. An alternative dragging coat is a mixture of glaze and oil-based paint over flat-oil, which gives a more opaque finish. As a third option for either a dragging or combing coat, egg-shell thinned to near-transparency with mineral spirits is effective, although it

Above *Dragging on furniture can be highly effective. Following the general direction of grain keeps the feel of wood but allows great freedom of color and finish. Here, the dragged finish forms a background for a stenciled floral design.*

Ferning

This technique creates a pattern that resembles the leaf-forms of frost on a window pane; apply the technique to a desk, table-top, door or wall area. Work downward (toward you) so that each successive curving stroke is superimposed on the last and they all draw in toward the center. On a desk-top, the apex of the leaf should point toward the desk chair. A 3D effect is achieved by dragging the first strokes with a soft brush, then combing the later ones.

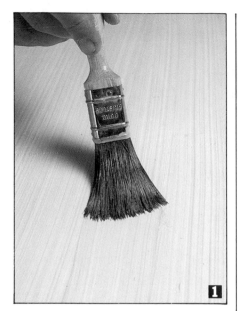

is a very quick-drying mixture and so less convenient for those unfamiliar with the technique. Oil-paint over undercoat gives the flattest of all finishes; here the stripes tend to merge together rather more, but this can often be most attractive.

You can drag with latex over an undercoat or egg-shell ground. This gives the softest of all combed effects, which can be very lovely, resembling very coarse parchment. It is difficult to drag or comb latex over a latex ground because it dries so fast on the porous surface and a latex ground won't stand up well to combs.

Whatever you use, it is always wise to test the tools, paints and their effect on paper before you start, and always keep the tools clean with the solvent appropriate to the glaze or paint.

■ **Walls** Dragging or combing a wall is most easily accomplished by two people. One should apply the glaze in a useful working band about 2ft (60cm) wide, while the other drags or combs steadily from top to bottom.

It is very important to keep the wet edge of the glaze "alive", especially if you are dragging horizontally, because if you let the glaze dry or become tacky, it is very hard to get an effective drag or comb stroke through it. If you then put more glaze over the top of the dried area and try to comb through that, you will get a patchy effect as the comb will remove the new glaze but leave the dark mark of the older glaze beneath.

It is best to keep the glaze brushed out to a fine, even film to

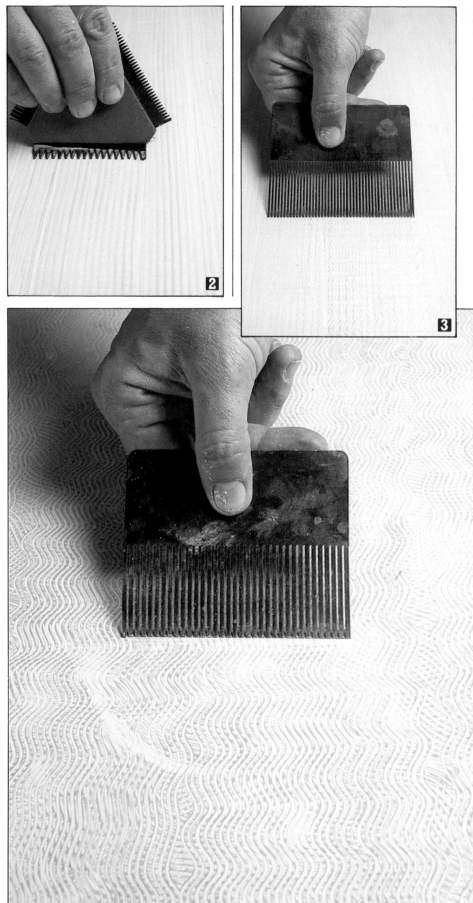

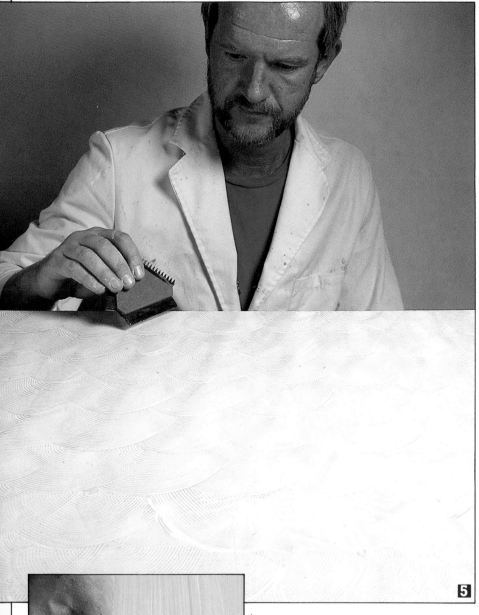

5

prevent it running. Always make the laying-off stroke downward, otherwise, unless you are putting on a number of glazes and drags to get a shot-silk look, the changes of direction will show through the tracks of the drag or combing as a wet-sacking effect; the wall will look slightly baggy and as if it is covered with wire mesh. It is, of course, always possible that you might like that effect.

When you are dragging, always be sure to wipe the glaze off your brush after each stroke or you'll just put it on again with the next and the definition of the stripes will soon become unpleasantly blurry. When you approach the base of the wall, lighten your stroke progressively as this will prevent a build-up of glaze from brush pressure. Go delicately around light sockets and switches, in the same way. Keep a rag soaked in mineral spirits handy to touch out any smudges. If you are planning two dragged coats, make sure that the first has dried out thoroughly before you add the second. If you use a water-based glaze, you must give the completed surface a coat of clear matt or semi-gloss varnish; this isn't essential for oil glazes, but it's always advisable.

■ **Woodwork** Dragging is better suited than combing to doors, baseboards and furniture. Combing on woodwork other than floors tends to look wrong, because it implies some mutation of the wood grain without actually resembling it enough to look intentional. Especially if you are using free colors — colors not natural to wood — combing tends to look incongruous. Dragging on wood can be done with smaller brushes than those needed for walls, but the method is basically the same. The essential difference is that you should follow the grain of the wood, even if that grain is not readily apparent under the base coat. Nothing looks more peculiar than woodwork that seems to have grain going in impossible directions, like a center-board in a door with hundreds of short, horizontal grains; to have cut a plank like that one would have to saw through a tree trunk 50ft (15m) thick — a Californian redwood at least — and such a plank would never hold together. Although you aren't simulating wood grain, remember that dragging on wood always implies a grain, whatever color you may use. On a door, follow the usual painting sequence of doing the panels in order and

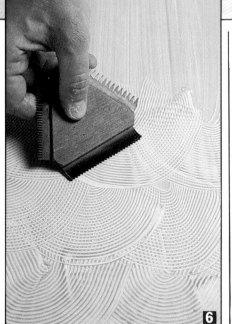

6

Combing sequence

1 *A soft brush lays on a loose paint gloss.*
2 *A coarse rubber comb straightens the lines.*
3 *A stiff, fine comb gives a kinked, herring-bone texture.*
4 *The same technique applied again, at right angles, creates a woven effect.*
5 *A fine rubber comb can be used to create a semi-circular fish-scale pattern, often seen on plaster.*
6 *A broad fish-scale pattern is achieved with a soft rubber comb.*

Right A cross-hatching effect is achieved with a soft dragging brush by crossing a wet paint glaze.

Below Dragging with a soft, flat brush gives a gently striated pattern.

Bottom Crossing a waving pattern with straight strokes, using a hard comb, evokes close-woven fabric — burlap or canvas.

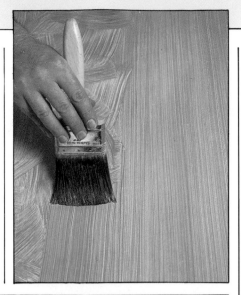

glaze/drag in one direction at a time, masking off each section and allowing it to dry before beginning the next. It helps to emphasize the joins between sections by a thin line in a neutral tone or slightly darker color than the glazing tone, either brushing this into a mark lightly scored with a knife, or filling in the score-mark with lead pencil. Other than this, the methods for dragging on wood are the same as for dragging on walls.

■ **Floors** Combing is better suited to floors than dragging, the soft, subtle texture of which is simply lost under foot and furniture. Combing can be executed on the bleached, primed wood of floor-boards and on floors of chipboard and hardboard. The parallel pattern of floor-boards, like the structure of a door, tends rather to dictate what finish is applied to them and most combing looks best following their direction and grain, whatever color combinations you may choose. These can range from mid-gray dragged over white, dark blue or mid-blue over pale gray, to scarlet over deep blue or magenta over golden ocher.

It is certainly easier to comb on the floor. Gone is the wobbler's bane of the vertical plunge to the baseboard that daunts the faint-hearted, and instead you can stop for coffee at the end of a floor-board without having to worry about the wet edge drying out. Hardboard and chipboard floors, with their smooth surfaces, offer extraordinary scope for patterning: effects range from those formed by diagonally wood-blocked floors to the curves and swirls one sees in marble. Combing can also produce the kind of parallel patterns seen on American Indian rugs or Spanish straw matting.

On floors, you must use flat-oil paint, undercoat or egg-shell. Latex will come off after only very little wear and is therefore unsuitable. As always, you must prime new wood and then put on a full-strength undercoat and at least two slightly thinned ground coats — preferably three. The combing coat should be a 1:3 mixture of mineral spirits to paint — thicker than you'd use on a wall. This is absolutely necessary to give enough body to the finish. You can use proper floor-paint, of course, but its dense texture is less suitable for the combing coat and the color range is very limited.

Remember that the oldest joke in decorating is the one about the person who paints himself into a

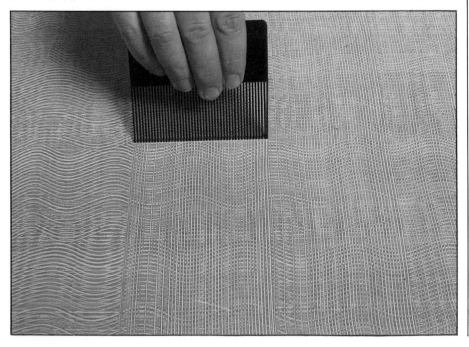

corner of a room rather than out of the door — and it happens. Always work toward the door. If you are making a pattern based on any geometric design, copy the design on paper first and divide it into regular squares; then, using chalk, divide the floor into scaled-up squares of equal number. Patterns with straight edges, where one direction of combing ends and another begins — like a chessboard made of contrastingly patterned wood — should be painted with masking tape along these edges and the floor grid should be painted in a checkerboard manner, with the alternate squares filled in once the others are dry. Floor-boards are best done by coating and then combing about two at a time. Once the combing coat is dry, give it three coats of polyurethane varnish. This will ensure that the finish is tough enough to withstand the type of treatment floors inevitably receive and will not detract from the coloring.

RAGGING AND RAG-ROLLING

Rag-rolling is one of the most varied and dramatic effects in the field of broken color. It is the foundation of all marbling techniques and is best done in pastel colors because its startling patterning can otherwise dominate its surroundings. Rag-rolling differs from ragging in that the cloth used is rolled into a sausage of varying tightness and rolled lightly across a glazed surface. This creates a sense of movement that an unrolled rag does not give. The pattern

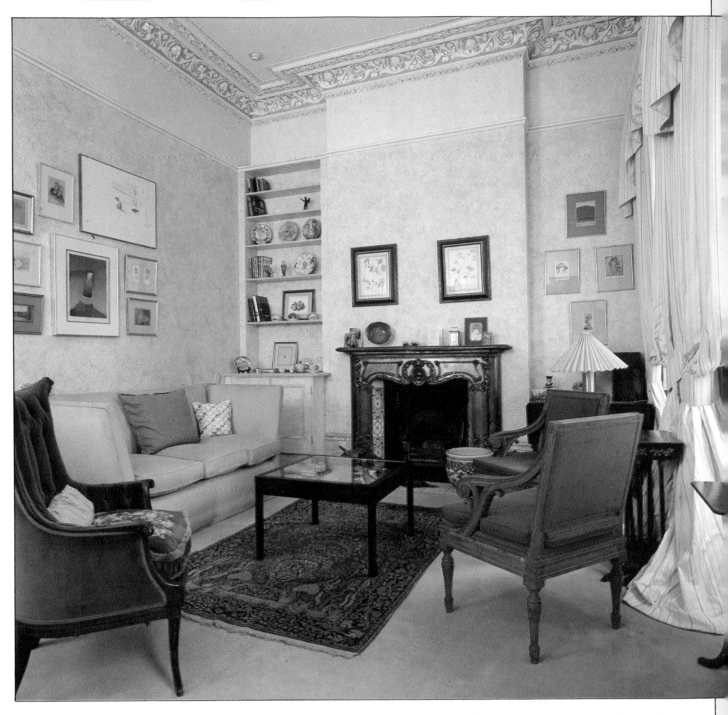

Above *Marble-like ragging suits an elegant context; here, it is in keeping with the picking out of the classical ceiling moldings.*

Top and far right *Camouflaging or assimilating inconvenient objects or blending sometimes awkwardly placed panelled surfaces is a particularly effective use of soft-toned ragging.*

Right *Marble-like rag-rolling of gray-blue paint glaze over off-white creates a visually interesting but relaxing finish.*

depends very much on the type of rag used; old sheeting, net curtaining, linen, lace, cheesecloth, jute and burlap are all suitable for rag-rolling, provided they are clean, lint-free and undyed. The crisper the fabric, the crisper the marking you get; the softer the cloth, the more various and subtle the effect. All marks left by cloth have a certain formality, though, and this gives a unity and rhythm to the surface finish that is otherwise seen only in some of the polished stones such as marble, or in the shifting yet harmonious sheen of crushed velvet.

As with combing and marbling, rag-rolling is more applicable to wall surfaces than to wood. There are a number of reasons for this. Primarily, the technique demands a reasonable amount of physical space to execute it and much woodwork is in places rather short of elbow-room. Secondly, the effect has often been emulated most inappropriately on latex enamels and, as a result of this misuse, ragging's application to wood can give the impression of latex enamel cut from panels that were designed for kitchen units — rather peculiar in a sitting room.

Also, applying ragging to woodwork as well as walls can deprive a room of form and contrast where it most needs it; the walls and woodwork may merge into a highly effective camouflage known as wave-mirror , used to hide aircraft flying low over water. A mottled vase on a rag-rolled table can vanish into a rag-rolled wall as effectively as two puffs of cigarette smoke into a morning mist.

On the other hand, rag-rolling can be used to make those banes of interiors, radiators, vanish with relative ease; the technique is well suited to their slab-sided form and they become one with a rag-rolled wall. On a wall, rag-rolling is really in its element and on the wide open spaces of ceilings it can be superb. It is particularly useful for visually defining surfaces that have an anonymous quality, softening angles, visually amalgamating oddly proportioned extrusions and alcoves and giving a sense of depth and sophistication to otherwise nondescript expanses.

Colors — especially those on latex enamel simulating rag-rolling — are usually muted because of the striking pattern produced, which might be too strident with louder or starker colors. Decorators tend to stick safely to light neutrals and pastels, but the potential variation is enormous. Linen, which makes sharp patterns with a soft-center effect within the stroke, can evoke crushed velvet when used with warm, wine-like colors — such as madder pink over magenta. This can be very oppressive if misused, but on small areas with soft light it can look sumptuous. If applied in light beige over cream, linen rolling can suggest a great sheet of crumpled paper or parchment.

Off-white grounds are highly versatile because you can put almost anything with them: off-white is a tint made with a touch of raw umber or raw sienna and looks superb with blue-grays such as French gray; gray-greens, caramelled pinks — pinks with a touch of ocher or burnt umber — and pale mustards. One of the most extraordinary effects is provided by rolling a white with a speck of black in it over an off-white ground, giving the effect of an old, damasked tablecloth. Then there is the white velvet effect of rolling off-white or a pale bluey-white over a stone gray.

Ragging — using a crumpled, unrolled cloth — has a more static

appearance to its glaze stroke, and with thinned glaze the texture of the cloth is often more in evidence. Ragging with burlap, using ochers and pale yellows, leaves a distressed leather or chamois leather effect; with cheesecloth the surface takes on an appearance of soft wool. Ragged linen can evoke surfaces from creased parchment to mottled trout-skin. Old net curtaining, paradoxically, can make a wall look like dusty canvas or can produce an effect of great softness, especially with cloudy colors like pearly mauve or duck-egg green. Lace achieves a finish that evokes nothing in particular but gives a delicate, shifting patina of color.

■ **Tools and materials** Conventional paint brushes are necessary for the application of the ground coat and a large, soft brush for the application of the glaze. You will also need an appropriate solvent, plenty of pieces of your selected rag and a sheet of paper for testing effects. The consistency and type of paint most suitable for ragging are the same as those for sponging, which is the most similar technique.

■ **Application** As with sponging, ragging offers you a great deal of freedom and you don't need to worry much about drying times, as it is a very speedy process. The technique on walls is to spread glaze over a fairly large area — certainly larger than the usual 2ft (60cm) wide band — and make sure it is brushed out to a fine film, as evenly as possible; excessive thickness will mean rag-rolling movements will collect a heavy patina as they shift the surface and a blotching effect will result. Test the glaze and rag first on lining paper, going up and down and across the surface to practice the movement and to see what effects you get. If the effect is too heavy, either loosen the cloth and use a dabbing action or use a lightly rolling one, as if you were rolling flour into pastry. When you begin to work on the wall, keep a sponge ready in case you make too hard a stroke across the glaze. You can then touch up at the corners with the sponge or dab further glaze on with it and re-roll, using another cloth of the same type. A chamois leather is also very useful for this. You should have no difficulty with the glaze drying out before you've covered the area but when you put on the next band of glaze, blend the two sections together with very light strokes, finishing off always in the

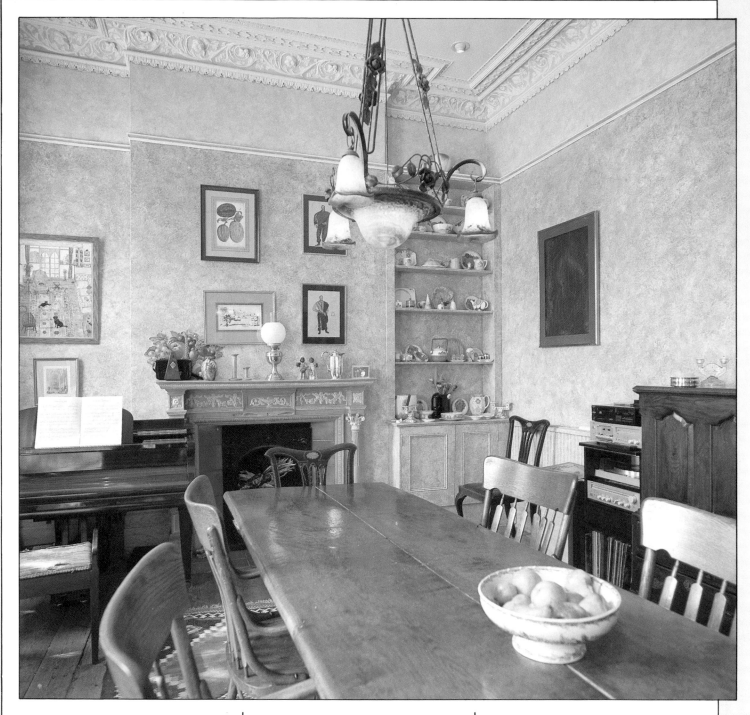

same direction and avoiding dark, creasing smears. Leave a few inches of the preceding area unragged near to the join until you have applied glaze to the adjoining section, to avoid brushing glaze into an already ragged pattern, and then you can rag in over the join.

The exception to this method of application is latex paint. Because it dries so quickly, latex needs two people on the job, one painting and the other rolling. It's preferable to put the paint on in narrow bands and roll straight over them. One great asset of latex is its softness of finish,

and rag-rolled latex wash can be very lovely but it is a tricky business. Oil-based glaze is far easier to apply.

Change the rags regularly as you work, and try always to use a uniform pressure to give a consistent finish. The cloth itself will ensure variety but this should imitate the effect of broken clouds on a sunny day: all are different, but their weight appears the same. If you intend to apply a second ragging coat, you must let the first dry out thoroughly beforehand. It is also advisable to make this second coat a lighter

color than the first. As you approach woodwork it's useful to sponge the effect up to the edges, gradually softening it, as it is often awkward to maintain the rolling movement as you near the margin of the wood. It can be effective to add a further tinted glaze coat over a single ragged coat but not to rag that; this gives a sense of depth to the wall surface. Remember to lay the unragged coat off uniformly downward, to avoid a disruptive hatching effect.

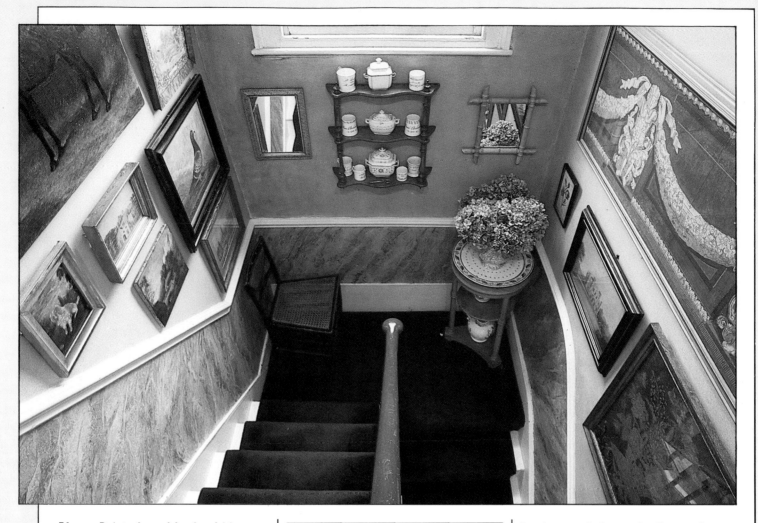

Above Painted marble should be toned to enhance what is above and beneath it. A white ground over-glazed with ocher and burnt umber, and crossed with feathered veining, links the dark brown carpet to paler colors above. Marbling all over this stairwell wall would be excessive and framed paintings hung on it would look peculiar; but on plaster above marble they work well.

MARBLING

Marble has been imitated by painters for nearly 3,000 years: examples of it date from Middle Kingdom Egypt. The success and variety of painted marbles are inspired by the similarity between flowing qualities of paint and the nature of the marbles themselves. Indeed, the very term marbling is used to describe a particular type of paint effect that frequently has no pretensions to imitating polished stone; it means a whirling, mottled flow. Real marble — stone marble — did actually flow when it was forming, and the first thing to realize when simulating marble is that a sense of movement is vital.

Marble is created by heat and pressure on limestone, which crystallizes in white, black and a whole gamut of more brilliant colors — literally, all the colors of the rainbow. As a result of mineral structures running through the molten strata and cooling, the vein-like forms appear and the fragmenting of layers, like the laminates of plywood, allows other matter to fill the cracks before pressure welds the layers together as a solid stone again. But marble, crystallized out of liquid fire, possesses an elusive translucence, that of swirling clouds in a multicolored sky frozen in an instant, as captured in a photograph of a bright storm. Its veins are literally petrified flame — and so light shines through them. Look at marble and you seem to be looking at veils; below its surface you see shadows and ghosts of other movements. It is variably opaque and translucent — and so is paint.

There are as many techniques of marbling as there are types of marble but the movement of marble is always diagonal and, amid the swirling freedom of paint, you should try to remember this. Even so, there is no need to be slavishly representational in a domestic interior. There are examples of marbling by masters of the craft — and indeed in fine art, where its appearance is an intrinsic part of murals of the High Baroque — where, to the naked eye, the result is

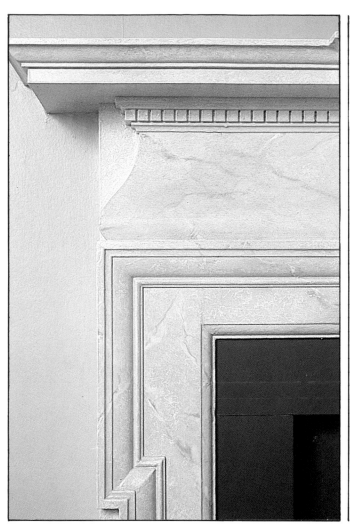

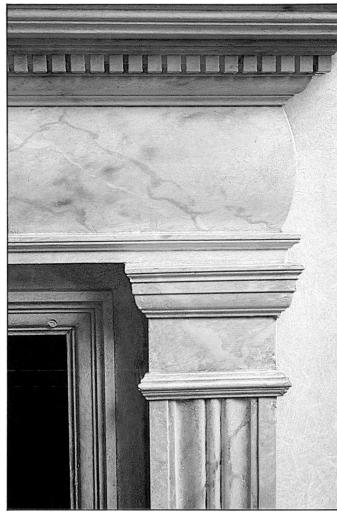

absolutely indistinguishable from the real thing; but such skill demands observation, augmented by talent and founded on an intimate knowledge of both paint and stone; it is neither possible nor often desirable for the amateur to attempt this, and it is good to bear in mind that marbling means an effect — just as a book cover may be marbled — and not necessarily a photographic representation of the rock.

In today's interiors, marbling works well on walls and floors, baseboards and mantels and large, solid furniture.

With the exception of matching mantel and baseboard, it is best limited to any one of these areas in a given room. In most modern buildings, a room that has been wholly marbled may well look awesome and even rather absurd, because the structure and proportions of so many buildings are not suited to marble construction; however, marbling just one area within a room can look superb. Bear in mind that although you are not

necessarily copying the stone, you are extracting its essence — its presence. As you are implying the presence of stone, you should marble only those things that might logically be made of stone. For example, a marbled, three-legged milking stool is a visual contradiction in terms but a marbled table, provided it isn't of too light a construction, can work very well. Mantels are frequently real marble, window-frames never are; and only mythological tombs have marble doors, to be charmed open by flutes or pried open by emissaries of the underworld.

The flowing crystals of real marble contain all the colors of the spectrum, and the cool or sumptuous beauty of the stone may be a consequence of any combination of these colors. This means that there is no limitation to the colors you may choose for simulated marble, at least in theory. The most frequent combinations of real marbles are probably the most harmonious and to follow them is often wise. Otherwise

Cissing

Cissing is the technique of spattering droplets of a thinner onto paint to achieve a random, mottled effect. Normally, mineral spirits are scattered on oils, and water on latex, but the other way around can often be highly effective.

Method I Load a fairly stiff-bristled brush with thinner and strike the haft against a wooden batten to scatter the droplets. This is most effective when marbling, for implying a mottle between veins; in porphyry; and for tortoiseshell.

Method II If the thinner is blown in a fine spray through an artists' diffuser onto wood graining, the resulting pattern evokes the tiny satin-like pores found near knots and around the heartwood. As patterning in its own right, cissing works well on furniture, and is an excellent addition to sponging.

White marbling sequence
1 Black thinned to a gray glaze is dabbed on with creased newspaper.
2 The surface is then softened with a dry brush.
3 Gray veins are applied using an artists' brush.
4 These are softened and smudged again with a cloth.
5 The whole effect is crossed again with a dry brush, to produce a delicate, misty result.

Far left Two mantelpieces show the finished effects of white marbling of varying density.

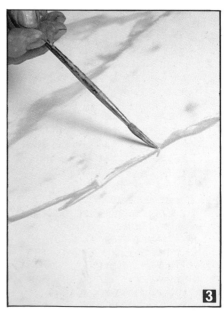

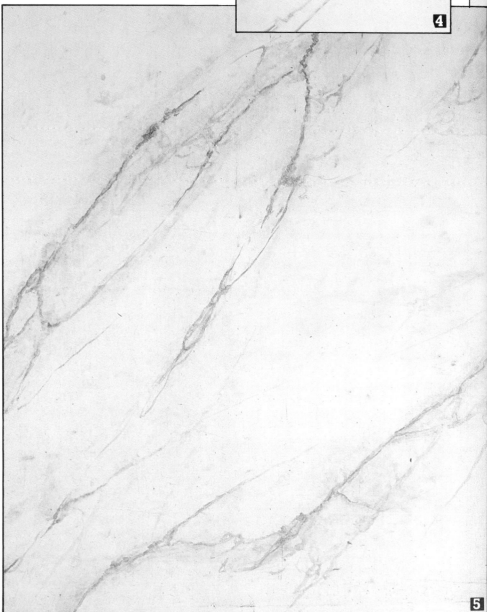

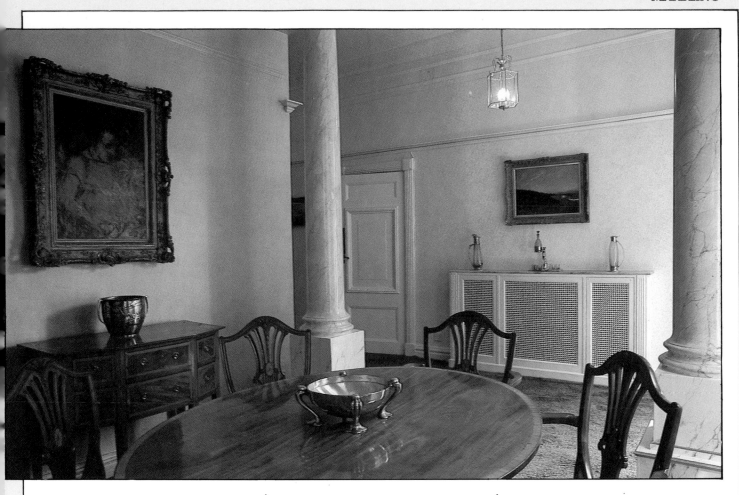

Above These marble pillars are restrained and their color is well balanced with the rest of the decor; more opulent coloring would make them overpowering.

you may end up with an effect less like marble than an infra-red map of the earth.

■ **Tools and materials** For all types of marble effects, you will need the same basic equipment: flat-oil, egg-shell or undercoat and a transparent oil glaze, in appropriate colors (*see below*); artists' oil in a corresponding color; oil crayons; a small marine sponge and a feather or a soft 2in or 3in (5cm or 7.5cm) paint brush , for "softening"; saucers, clean rags, screw-top jars and mineral spirits.

WHITE SICILIAN MARBLE

■ **Application** There are three basic techniques for this marble. For each of these, the base color is dead white — applied in flat-oil, undercoat or egg-shell — rubbed down with glass-paper to eliminate any brush strokes or unwanted marks. The surface should be perfectly level and smooth, as marble doesn't bulge. The other materials for this effect are artists' oil color in Chinese or flake white, raw umber, black and yellow ocher, and oil crayons in black and dark gray.

Method I First, blend a little of the white oil color with mineral spirits

until it is a near-transparent mixture. Then, separately, dissolving the oil color in mineral spirits and adding an equal amount of glaze, mix a small amount of each of two glaze shades, a yellowish gray and a greenish gray. For the yellowish gray, mix white plus raw umber plus a little yellow ocher and black; for the second, white and raw umber and a little black. Then, taking a rag, rub the thin, white oil mixture all over the surface of the prepared undercoat base color, so you get a milky, off-white effect like cloud.

Next, draw in the veins with the wax crayons, using the gray one for the softer, inner veins and the black for the harder, outer ones. Let the vein pattern meander diagonally over the surface. The pattern is rather like a bolt of black lightning striking across a white sky Remember that marble veins spread like a tree's branches, to left and right of a central node on the stem; so, on a wall, imagine the sparse crown of a tree upside down and then another spread of bare, twiggy branches rising from the floor until they all meet and join up. Or, if you like, picture it as a series of raggedly diagonal rivers, all running across a

map; but remember, the branching tributaries of these rivers *always* join up again eventually; they never appear from nowhere nor do they just peter out to nothing. Be as free and sweeping as you like, but take care not to overdo it; always err on the side of too few lines rather than creating the vast web of some manic spider. There should be big, wide areas, across which these lines meander with wide spaces between. The only crowded or busy areas should be where one set of veins crosses another. Put the pale gray lines on first and then follow them like ragged tracks with the darker shade.

When you've finished veining, sponge the large white areas with the gray-green and yellow-gray glazes; do this sparingly and don't entirely cover the white ground. Then, with a broad, dry paint brush, strike the whole surface diagonally one way, and then the other. This will make the crayon lines and glazes blend softly, and the whole effect miraculously seem to resemble marble.

Above *Rose marble and pink-veined white: two effects achieved by reversing the same colors, rather like a photographic negative. Note the broad fluidity of the veins on the right and the delicacy of those on the left.*

Method II This technique avoids the laying of the white oil over the base coat as in Method I, and uses just the white base coat instead. With a mixture of 1:2 parts of paint to mineral spirits, mix a paint glaze of raw umber and black, which should have just enough color to show against the white ground. Sponge this over the whole surface. Then, using two different mixtures of raw umber and black, to give a light shade and a dark shade, mix the two tones for the veins. Taking a very slender artists' brush, hold it straight out as though it were an extension of your hand and, keeping your palm upward, rotate the brush gently as you draw it across the surface toward you, varying the pressure to vary the width of the line. Soften these lines a little with the sponge and transfer some of the darker color on the sponge to other areas adjoining the lines, to achieve a delicate bruising effect. Then go over the whole surface again in one diagonal direction with a dry brush.

Method III Replace or augment either the wax crayons of the first method or the artists' brush of the second with a long feather. Dip the edge of the feather in water and then in mineral spirits, and then comb it to separate the fronds. To create the veins, brush some oil color onto the fronds and draw the feather across the surface. When you turn it side-on to the wall, the feather will leave a sharp, single line; tilt it, and the frond lines will branch in all directions; turn it back on edge again and the lines will coalesce sharply into a single vein again. This is most effective if the soft veining colors are used in conjunction with wax crayon. You can create a very soft and subtle effect by crossing the veins afterwards with a dry brush.

ROSE MARBLE

■ Application

Method I This marble can have a base color of soft, sandy gold — beige with yellow added and a spot of red — with a pale pink glaze brushed over it. This glaze can be applied so that there are corridors or canals where the base color is left to show through. These unglazed, linear patches may be quite wide — up to 6in (15cm) — so that they form wide, sandy veins across the rose-colored areas. Then, mix a glaze of 4:1 parts blue to red, with a touch of white and a trace of burnt umber to give a gray-purple. Sponge or brush this loosely over the pink-glazed areas. After this, dab the surface with a crumpled newspaper, to give a soft, creasing effect. Veins of thin white can then be traced onto the surface with a feather or an artists' brush, crossing over the purple/pink areas as well. The whole surface is finally softened again with a dry brush.

Method II A matt coat of deep pink or gray-pink — magenta, white and a touch of black or gray — should be laid on over a light gray base coat, in the same way that the white ground is laid over the base coat in Sicilian marble. This should be over-glazed

Top The exotic element in marble combines admirably with objects of fantasy.

Above Tone co-ordinates these two colored marbles, the darker adding visual weight to the stairway, and stressing the sweep of its form.

with a thin white paint glaze, followed by an ocher glaze laid in rough, feathery diagonals. These should be softened with a dry brush and then, either with a feather or artists' brush, a deeper blue and red glaze should be applied to evoke veins, roughly following the ragged, softened, ocher veins. To finish off, the whole surface may be softened with a dry brush.

BLACK SERPENTINE MARBLE

The first method given for simulating serpentine marble is simpler to execute than the Sicilian effect, except that it needs to be done horizontally because of the flow of the paint. The second is perhaps rather less easy, but allows a vertical approach. In either case, black serpentine is a very beautiful and dramatic marble and should be simulated sparingly. In small amounts it can be superb, *en masse* it tends to be somewhat oppressive.

■ Application
Method I For purposes of simulation, at least, serpentine has a black ground, mottled with a dusty emerald and streaked with random, thread-like veins of white. Lay the ground with black, oil-based paint, then mix the top coat of green paint glaze — emerald with a touch of raw umber and black to dirty it or take the edge off it. Mix this in a ratio of 1:2 parts mineral spirits to paint, so that the glaze has a reasonable body. When you've applied the glaze, take a stiff brush and splash mineral spirits at random all over it by flicking the brush. Where the mineral spirits fall irregular apertures will open in the glaze to reveal the black ground, a process known as cissing, an effect that can also be obtained by flicking water over oil-based paint. Next, squeeze a marine sponge out in thin white paint glaze and dab it on the areas of black ground revealed by the cissing, so that an occasional mottle of white results. For the veins, it is highly effective to coat lengths of cotton thread or thicker twine in white oil color and lay them on the surface to produce a random flow and an occasionally crossing fretwork of fine, diagonal lines.

Method II This involves using oil- and water-based paint together, and enables you to achieve this effect on a vertical surface. A black, oil-based ground should be applied in the usual manner, and over this a black oil-based coat, thinned in a ratio of 1:2 parts mineral spirits to paint. This should be laid on so that there are still patches exposing the dry base coat and also thin, linear areas of veins joined to these patches. While this is still wet, unthinned latex in white or very light gray can be taken up very thickly with a marine sponge and dabbed lightly on the surface where the wet, black glaze coat has not been applied. You will find that latex will flow into the wet edge of the oil. Using either a feather or a thin artists' brush, held in the manner described for Sicilian marble, roll the latex along the linear vein spaces left in the oil coat, fairly liberally, teasing it into the edges of the oil coat. You will have islands of hazy, swirling mottle where the sponge has been, linked by hazy veins of white. Add very fine lines by laying cotton strands, liberally coated with latex, against the wet oil surface; hold them at both ends and slap them against the surface. The natural action of the water-based paint floating on the oil surface often means the surface doesn't need brushing afterwards, but a dry brush can be used to soften areas where the effect is in any way short of the desired finish. Over this, when dry, should go a thin, emerald glaze. When this has dried, the surface should be given a clear coat of matt or semi-gloss varnish to prevent a different texture occurring and catching the light between the two types of paint. Brushes used for this process should be washed out in mineral spirits and then warm, soapy water.

RED MARBLE

Rose marble has a soft, glowing quality to it, whereas red marble has a deep, sumptuous appearance, the difference perhaps between silk and velvet. Like black serpentine, the red marble pattern is exotic and best used sparingly. Its ground is an orangey magenta, rather like a punch made of red wine and pineapple juice. The grain or vein of this marble evokes a ragged white net or the diamond-shaped mesh of a wire fence that is encrusted with ice and torn in places.

■ Application
Method I Over a dark gray or brick-red base coat, brush or sponge a ground color of 4:1 parts deep pink to yellow ocher with a touch of blue, thinned by about a third with mineral spirits. Mix an off-white glaze — flake white and yellow ocher — and, using a feather, simulate a wide-spaced

Above *A green marbled, varnished mantelpiece adjoins a ragged amber glaze chimney-piece and a yellow Sicilian marble.*

Varnishing Marble

All painted marble should be varnished to protect it, and polished stone generally has a satin finish. Apply two coats of clear gloss varnish and one of satin to walls and woodwork, and four coats of gloss plus one of satin to floors. A tinted varnish applied to white marble gives a very attractive, deep, translucent tone and results in an aged appearance, often found on mantelpieces and marble-topped furniture.

Right: Sequence for green marble
1 *Broad ruffles of green glaze are applied over black with a feather.*
2 *The surface is cissed with mineral spirits, sprayed from a bristle brush, to open up the pattern.*
3 *A mixed green and white paint glaze is feathered cross-wise over the preceding green veins.*
4 *Fine white veins finish the effect.*

version of the mesh pattern. Soften this pattern by crossing the edges of it lightly with a dry brush, leaving the central strokes of the veins fairly crisp. When this has dried, go over the whole with a thin, light blue glaze. Finally, in the center of the junctions where the veins of the grid cross, use an artists' brush or half a potato to add flecks of deeper magenta or magenta and blue.
Method II This is a similar technique to that of using oil- and water-based paint to simulate black serpentine. After applying a brick-red base coat, apply a second of the same colour with a trace of blue and a touch of yellow ocher. While this is still wet, float an off-white, ragged mesh pattern of latex over it in the manner used for black serpentine. When this has dried, the veins may be strengthened with a feather.
Method III This is an exact reversal of the preceding technique. Over the base coat of brick-red, apply the ragged vein mesh with off-white, oil-based paint, using an artists' brush or large feather. Then fill in the areas between the veins with latex. Where you brush or sponge the latex up against the oil-based veins, a soft swirling and blending

will occur, and fine wisps of the oil-based paint will be carried like threads into the latex. This is perhaps easier to apply than Method II, as oil-based paint is more dominating than water-based, and in the second method there can be a danger of the water-based veins being "drowned" in the oil surface and disintegrating. This third method is also rather quicker, as the quick-drying latex means that at least two-thirds of the area is dry and can easily be touched up while the remainder is blending; while in Method II, the whole surface is liable to be wet for a considerable time before you can strengthen any areas that are not satisfactory.

GREEN OR TERRA VERDE MARBLE

This is probably one of the most attractive of marble patterns, as it has the panache of black serpentine but is less stark. Its salient features are a moss-green ground with shifting, deep blue clouds across it, veins of ocher and gold and then serpentine veins of white crossing the deep blue-green. Occasionally it may have a gold flecking, which can be added by a very fine spattering.
■ **Application** Over a base color of flat-oil, undercoat or egg-shell in a dark- or mid-green, apply a paint glaze of 3:1 parts artists' oil paint to mineral spirits, to give a blue-green clouded effect. This oil color should be 3 parts ultramarine blue, 1 part emerald and 1 part burnt umber. Brush or sponge this glaze liberally all over the base color, leaving sizeable areas uncovered by it. Then, using an artists' brush or a feather, add the yellow veins: they should consist of an oil glaze with 3 parts yellow ocher, 1 part red and 1 part white, and be allowed to meander as they do in Sicilian marble. Cross the veins with a dry brush to soften their lines and, if necessary, strengthen the inner parts of the veins afterwards. Then, using lengths of cotton thread soaked in white oil paint, lay sinuous, white veins across the blue-green areas between the yellow veins. The yellow veins should be much broader and more powerful than these thin, white lines; all are diagonal, but the white should appear like little shoals of eels passing through wide, green spaces in a gold mesh net.

If you want to create the effect of gold flecking, take a dry 3in or 4in

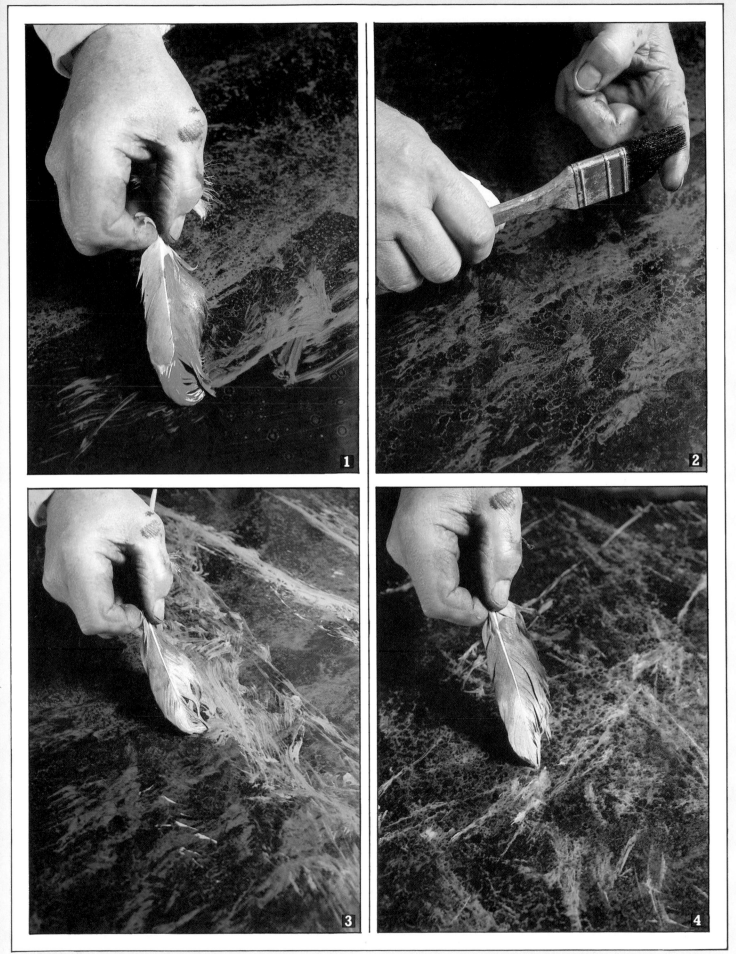

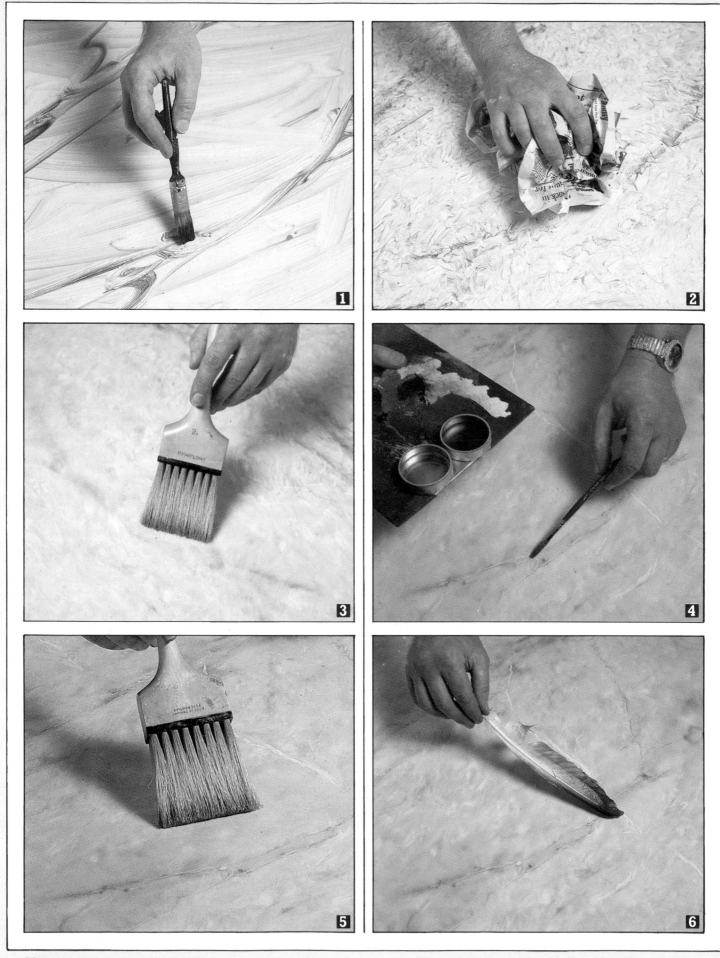

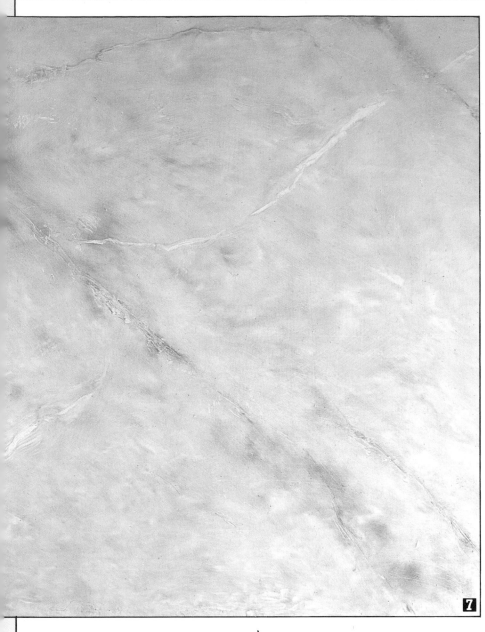

mid-blue, and over this a series of glazes is applied, more evenly spread than for most marbles.

■ **Application** Mix a thin oil glaze of ultramarine, 1:2 parts paint to glaze, and brush it all over the base color. Then, using a feather or artists' brush, lay swirling veins into this glaze, in an off-white paint glaze — 3:1 parts paint to mineral spirits. This resembles Sicilian marble but is more fluid, like cigarette smoke. Over these and the blue areas, apply another thin, blue glaze so that the whole effect is pale and deep blue. Next should go a slightly thicker colored glaze of magenta, leaving some patches uncovered to give a purple-blue, bruising effect; then, using cotton lines coated with white paint, add thin white lines along these bruised areas. Soften the whole with a dry brush, giving a thin, overall glaze of emerald as a finishing touch.

OTHER TECHNIQUES

The preceding marbles are an example and guide. To begin to enumerate all the possible colors and variations of this stone would be to recite the color wheel in the form of veins and grounds and base coats. There is simply no limit to the colors you can choose and the only limits to the technique are set by the materials you use. With an oil-based paint glaze, mixed 1:1 with mineral spirits, you can virtually marble on any ground in any color. You can mix three or four glazes of different colors and spread them over the ground and blend them, dabbing the whole surface with a marine sponge or creased paper. By adding transparent oil glazes of lighter and darker hues, you can create a feeling of depth in the finish that is peculiar to marble as a polished rock and gives it that element of clouds and tinted veils that is the prime secret of its light-retaining quality. Spattering any color in showers of fine flecks can be effective, provided that it isn't overdone, as most marbles do not include too many of these isolated crystals. However, spattering mineral spirits or wood alcohol in the same way — even on a vertical surface — is almost always highly effective, as it opens the glaze for a cissing effect. It also works very well on blue and rose marbles.

Left and above: Sequence for yellow marble
1 An ocher glaze is brushed loosely over a cream ground and rough veins of dark brown added with a smaller brush.
2 The surface is ruffled and blended with crumpled paper.
3 The whole is softened with a dry brush.
4 Blue and sepia glaze veins are added with an artists' brush.
5 These are softened with a feather or broad brush.
6 Fine white veins, unsoftened, are applied with a feather tip to cross the existing pattern.
7 The fine white veins appear to float on successive layers of color.

(7.5cm or 10cm) brush and coat the ends of the bristles with gold enamel paint. You may need to thin this paint slightly with mineral spirits, about 1:4 parts mineral spirits to paint but no more. Hold the brush 6-12in (15-30cm) from the surface and run a steel-toothed comb across the bristles in a single saw-stroke, to give a soft spray. The flecked areas occur in the blue-green patches among the thin, white veins. It is somewhat easier to use this method than a canned spray, which tends to give too dense a delivery to the surface for this marble.

BLUE MARBLE

This is an effect like deep blue, clouded glass. The base color should be a flat-oil, undercoat or egg-shell in

PORPHYRY

The name 'porphyry' comes from the Greek word for purple, the reddish purple associated with the Caesars. The term was and still is used to describe the red-purple variety of an igneous rock, which can be polished like glass and was frequently used for figurative sculpture. But this hard, granitic rock with its crystalline drifts occurs in many color variations: dark green flecked with gold and black; violet flecked with gold, black and iron-gray; red-brown flecked with light brown and black, or with red-purple, black and pale pink; brown marble-veined with almost translucent white and flecked with pink, red and green; or gray-green with flecks of white and black.

Porphyry as a paint technique is really a specialized variant of spattering. It is easier than marbling, once you are acquainted with the technique, and is applicable to wall areas of most sizes, especially those of bathrooms and small hallways, floors — provided the patterning is not too pale — and the tops of some furnishings, especially side-tables; it can be used contrastingly on baseboards and mantels. It can be far lighter in appearance than tortoiseshell and, as with marbling, there is no real constraint on the colors you may use. However, even when used with free color combinations, the technique still evokes a stone-like quality and not just a pleasing, but random, paint finish like spattering.

PINK OR CINNAMON PORPHYRY

This is a deep cinnamon-colored rock, flecked with pink, red and green, and sometimes with smoky veins of milky white.

■ **Materials** The ground color should be flat-oil paint or undercoat tinted with artists' oil color in beige or mid-brown; use a dark red and trace of black with the beige, an orange and black with the brown, and blend 1:6 parts oil color to paint. Also necessary are flake white and opaque oxide of chromium (mossy

gray-green) oil color, mineral spirits, ordinary large paint brushes for the base color and smaller (2in and 4in (5cm and 10cm) ones for spattering. Optional extras include oil glaze and an artists' diffuser; this is a very simple piece of equipment, consisting of two small, hollow tubes set at right angles to each other, which you can get inexpensively from any artists' supplier. A small artists' brush or large feather is also required.

■ **Application** When you have tinted and applied the base color, allow it to dry thoroughly. Meanwhile, mix six variations of the spattering colors. All should be diluted with mineral spirits in a ratio of 1:3 paint to solvent. From the base color, make two pale coffee browns by adding flake white, one slightly darker and "dirtied" with a spot of lampblack; two greens, one by adding flake white to opaque oxide of chromium, the other flake white and a trace of red to the opaque oxide; two pinks, one by mixing flake white and red, the other flake white, red and a trace of opaque oxide. Also make a 1:3 paint to solvent dilution of flake white.

If you decide to include a white vein pattern, take either an artists' brush or a feather and, in the manner of marble veining, apply a loose, swirling, slender sinew across the surface — as if you were imitating a wisp of smoke. This veining should meander and it can split, but it should always ultimately go to the edges of the surface, never just stopping. If you do not think the effect is soft enough, use a dry brush to cross the veining as you would in marbling, then commence spattering. Whether or not you apply the veins, begin spattering with the deeper of the mixed oil colors: the deeper green followed by the deeper pink, then the paler green and pink, and finally the two off-whites. You can, if you choose, apply a glaze between some of these coats, to increase the depth of the surface effect, but this isn't essential. Remember, though, that porphyry is a crystaline rock, and the spatters which evoke the mineral crystals don't have to be as regular as, say, the spattering of a non-representational pattern that relies on a more even, stylized finish. But don't overdo it; you rarely see porphyry with a mottle larger than ¾in (1.8cm), the great majority of sizes ranging between wheat grains and fuzzy rice seeds up to garden peas. Often there are fine, mottled

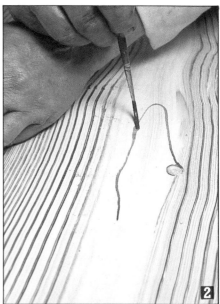

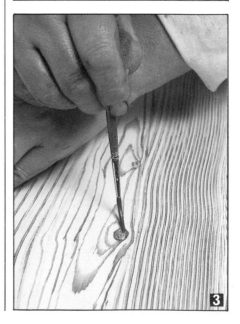

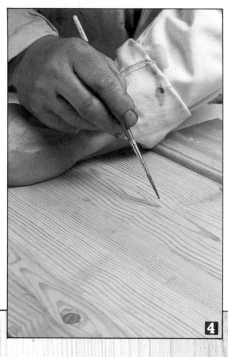

Sequence for wood graining

1. A paint glaze is brushed on freely, and then either a wide or narrow comb or two or three fingertips wrapped in a soft, clean cloth remove the paint in grain-like, wavering parallels.
2. Finer grains are drawn in with an artists' brush or sign writers' liner over an area wiped clear with a cloth.
3. Knots are touched in with a finger-tip and then strengthened with an artists' brush.
4. The fine grains are thickened into long ovals around knot and heart-wood sections.
5. The final finish of this method is an unrepetitive, almost photographic realism.

clouds like the Milky Way, and these are very easily created with a diffuser. You put one end of the tool in a pot of thin paint and blow gently through one of the two remaining apertures. This draws paint up to the junction of the two tubes; another puff dispatches a fine rain of paint from the remaining outlet onto the surface. It is quite straightforward, so long as you remember not to suck. For larger spatters, strike the haft of a loaded brush against a flat piece of wood; for the finer crystal spots, load a stiff-bristled brush at the tips with the spattering paint, then draw the teeth of a stiff comb or a knife tip in one sawing stroke across the bristles, creating a fine spray.

If you are working on a flat surface, the finish can easily be cissed by spattering mineral spirits over it. This opens up the paint and, if you have applied a glaze, it will produce an appearance of bursting and expanding crystals where the solvent strikes the spattered paint spots. This is also possible on a vertical surface, but keep a rag handy to soak up any dribbles quickly.

This basic method of application is the same for any porphyry, regardless of the colors used. Remember that you always lay dark spattering colors first, with the lighter shades laid on top to give the surface a greater effect of depth.

Porphyry has a variety of finishes. It can be semi-matt, like roughly worked granite, or it can have a glass-like, high gloss finish — that enamel-like polish seen on much finished statuary. On walls, it looks best matt or with a soft sheen but on smaller areas such as baseboards, panels and furnishings, it can have a more reflective finish. In all cases, porphyry should receive two coats of clear varnish; otherwise, when you clean it, polishing will damage its fragile spattered surface. A satin finish probably gives it the best degree of shine.

WOOD GRAINING

Like so many other decorative techniques, the craft of simulating wood grain dates from Ancient Egypt, a land traditionally short of wood; the technique was thus developed to imply the presence of a costly material, hard to obtain. Centuries later, in Europe and elsewhere, similar techniques arose to imitate rare exotic woods. These techniques have been developed to

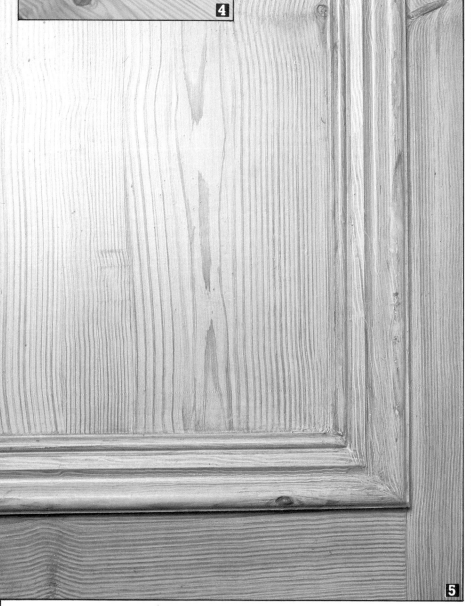

a high level so that the combined understanding of paint and of the properties of wood have produced simulations indistinguishable from the real article. Many of these involve the manipulation of tinted varnishes, similar to the technique for tortoiseshell; others require over-glazing oil paint, then applying a coat of varnish. Most of these almost photographic simulations are outside the scope of the amateur, but there is really no need to attempt them. As with marbling, the chief asset of graining in most interiors is its general effect, the sense of texture,

warmth and that organic harmony that is peculiar to the grain of wood.

Woods are so various and the contrasts of their grains so great that most graining techniques set out to take the general principles of wood's structure and treat them in an informal, but recognizably organized, way. Graining as decoration is seldom, therefore, a study of a particular wood — be it pine, beech, rosewood or mahogany. These four are so different that they are an ideal example of the futility of attempting a generalized technique, aimed at reflecting all four.

straight. Like rippling water, it is infinitely various, but it does have a specific, unmistakable pattern; it is never anarchic. These are the general features of softwoods and the majority of hard, though in hardwoods the grain is usually much finer and closer.

In the majority of cases, it is useful to use a series of tones of the same color when graining. Establish the general tone of the wood, say, light oak — a pale gray-gold — and then, choosing a base color slightly lighter than the intended finished color effect, add the grain in slightly darker tones. Even so, it is quite easy to produce contrasting grains of a different color, or to over-glaze wholly different colors on top of those used for the graining itself. Contrasting grains can be as gentle and subtle as silver-gray oak — that is, a dark gray ground with a trace of ocher, with the grain in a pale gray or off-white. With careful choice, a pleasing grained effect can be produced in colors that have no natural connection with wood itself, such as amber grain over emerald, or emerald grain over deep gold.

The essential structure of the grain can be stylized and conducted with a considerable degree of fantasy; but if you exercise this licence, guide it with knowledge. Take a rubbing of a wood grain with a wax crayon or charcoal on paper to give you a graphic view of its structure and make you familiar with its more prominent markings. Also, coast a dry brush over the grain of wood to give yourself a feel of its flow and way of growth. Close your eyes and allow your touch to dictate to you or, still with closed eyes, run your fingertips over the surface. Then emulate this motion with your hand away from the surface. Having said all this, there is no need to become too studious about graining as the ultimate aim is a decorative effect, not a photo-realist painting.

Above A fine example of delicately tinted wood graining on floor and window paneling. The variation of the grain is considerable, but all the sections have the same visual weight and the result is a highly sophisticated, quiet unity.

If you intend to simulate wood grain, it is a very good idea to look at real wood for a while and study the way it has grown or "flowed" before you begin work. Notice how the heartwood shows long, ragged ovals with the grain widely spread and softly defined, forming broad areas, not sharp waves. See how grain usually runs roughly parallel, while rippling gently and rhythmically; how it grows darker as it approaches a knot and swirls around it, and then pales as it passes beyond. Notice that at times the grain draws apart, is broader or narrower, and how even at its straightest is never really

BEER AND VINEGAR GRAINING

Either oil or water-color paints can be used for graining, and beer or vinegar mixed with water is probably the cheapest version of the water-colors. The ground for this technique needs to have a flat finish, so flat-oil paint or undercoat is best, sanded down with wet-and-dry abrasive paper and soapy water. This sanding should be carefully and thoroughly done on egg-shell paint to ensure good adhesion and to flatten

the sheen. The chief problem with using water-color on an oil ground is that globules of water tend to form on the surface rather than spreading in an even film. For this reason, it's advisable to run over an oil ground with whiting on a damp sponge and then dust off the loose whiting powder when dry. Rubbing the ground with soap solution will also help to eliminate grease spots that will otherwise cause color to ciss.

Stale beer — preferably brown ale because of its high sugar content — mixed at a 1:2 beer to water ratio, is capable of giving a variety of shades from deep amber to pale gold when applied with a brush. Malt or red wine vinegar and water at the same 1:2 ratio gives a slightly redder tone (don't use onion vinegar — it is too pale); it's a good idea to add a little sugar to this solution to help it stick to the surface — about 2tsp:1pt (10gm:600ml). Either mixture can be tinted with powder pigments by mixing the pigment to a smooth paste with a little of the beer/water or vinegar/water mixture first and then gradually stirring them into the main body of liquid.

These beer or vinegar stain/paints have a translucency that can give a remarkably sophisticated finish if they are used with care. In fact, the sap that produces wood grain is not dissimilar in consistency. The softness of the colors also means that they can be strengthened with additional brush strokes without building up a sticky layering, which is what tends to occur when thickening other types of paint. They can be blurred softly along the edges with a damp sponge, and it is even possible to evoke the ragged ovals of heartwood by laying on a long oval area of water with a sponge and then coasting a brush loaded with beer or vinegar stain down each edge. The inside edge of the stain stroke should haze and blend, fading in toward the center of the oval. The other grains can be applied with an artists' brush, from 1/16in (0.15cm) upward, a ½in (1.2cm) being about the best general width for washing in between the grains, and a ¼in (0.6cm) the most suitable for the grains themselves.

■ **Application** There are two main methods for beer or vinegar graining. The first has much to do with the basic techniques of all water-color painting, and the second with dragging — a method also used for oil-graining (see below). The water-color approach involves drawing in

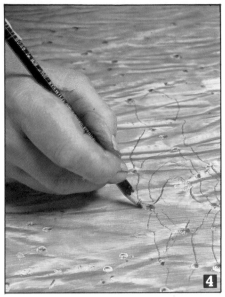

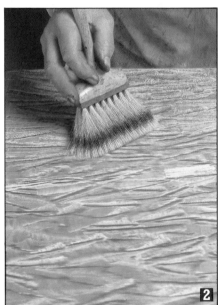

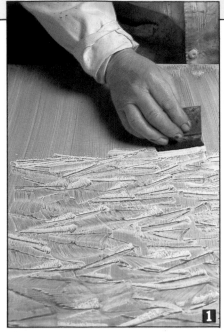

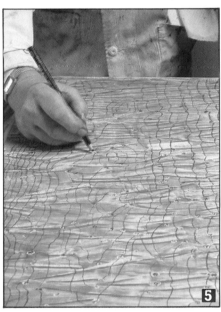

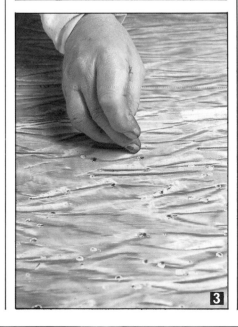

Sequence for simulating bird's eye maple

1 *A generous paint glaze is laid over the ground and a series of rhythmic crinkles achieved by using the end of a soft rubber comb, pressing right down, then releasing sharply upward.*
2 *This effect is softened with a badger softener.*
3 *The "bird's eyes" are blotted in the wet glaze with a fingertip.*
4 *The eyes are joined with a soft pencil in the manner of grains.*
5 *The result is a highly stylized version of this maple.*

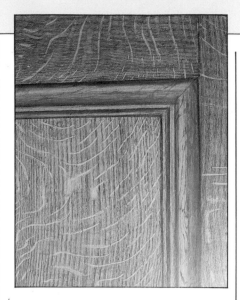

Above *This effect was achieved by paint glazes applied as on page 107 but using a grayer tone. Then the cross-grains were scraped out of the wet glaze with a clean, round-edged tool, such as a pencil wrapped in cloth.*

Three Decorative Woods

Rosewood A rich auburn paint glaze should be brushed evenly over a mid-brown ground. With a feather or a ¼in (6mm) artists' brush, grains of deep burnt umber should be laid on in sweeping parallels that swerve jaggedly sideways for a few inches, at roughly 18in (45cm) intervals. Soften with a broad, dry brush.

Walnut A soft, deep, honey-brown paint glaze should be applied evenly. Then with a feather or ⅓in (8mm) artists' brush, veins of deep coffee (2:1 burnt umber to raw sienna) should be added to look like a shoal of eels wriggling side by side, each between a few inches and 2ft (60cm) long. Soften the overall effect with a dry brush until the pattern is foggy.

Oak Evenly apply a gray-brown paint glaze of 2:1 raw umber to burnt umber. Extend grains of burnt umber outward from a knot in concentric ripples on one side of the knot, and on the other extend them as wavering, parallel lines. For these veins use a ¼in or ⅛in (6mm or 3mm) artists' brush.

the grain lines with a brush, in the same manner as you would use a pencil; a sign-writers' brush, known as a pencil writer, is highly effective for this. Load the brush to about a third of the way along the hairs, but not so much that it drips. Holding it as you would the shaft of a pen, rest the tip on the surface and, in a continuous movement, draw the brush downward; the good news is that you don't have to worry about wobbling, but try not to let the stroke appear "tight" — full of little kinks. This will happen if you hold the brush too tightly and go too slowly. Practice on some paper first. To soften one side of a piece of grain, either take a larger brush, dampened but not dripping, and tease the edge of the grain stroke; or lay a stroke of water down the surface before you make the grain stroke and let the grain line follow along the edge of the wet area. Keep a sponge handy at all times. Knots can be simulated by laying a circular patch of color on the surface and pressing a dry, notched cork immediately into the wet area, or a torn, screwed knot of blotting paper, which is often more effective.

There are two great assets to this method, besides being inexpensive. Firstly, it dries very quickly, in about 15-20 minutes, which means you can touch it up without worrying about smudging the parts that you have already done; and secondly, that it can be washed off immediately after application if you haven't got what you want, provided that you've sealed the surface first. Some people consider the quick drying a drawback, as you may not achieve the desired effect before it dries; but this scarcely matters since you can still wash it off when dry. In any case, you can slow the drying time by adding a few drops of glycerine. Probably the prime limitation of this medium is its delicacy; like so much water-color work, it looks best fairly small. To undertake a very large area can make the effect appear too fragile for the space, so it is best to stick to door panels and small, inset areas.

It is absolutely essential to protect water-color of this type with at least two coats of clear, semi-gloss varnish, otherwise it can easily wash off or wear away.

GLAZE GRAINING

This is graining in oil, using a transparent glaze over an egg-shell ground. The ground should be hard, smooth and non-absorbent; if you use a flat-oil ground, you should give it a protective coat of clear shellac or satin-finish varnish before graining. The basic technique involves brushing glaze over a ground color and then giving the glaze a texture with a graining comb or a dry dragging or graining brush.

■ **Materials** The correct tools are essential for graining. These can be expensive and so, even if you don't wish to splash out for the real thing you absolutely must get the nearest approximations.

You need a medium-sized decorators' brush for initially applying the glaze color. Then a graining brush; you can easily make one yourself from a stiff, thin-bristled brush by chopping the bristles off square about 1in (2.5cm) from the stock with a craft knife and a hammer, and then cutting out clumps of bristle from each side of the brush, alternating the clumps and leaving a slight space between them. You will also need a graining comb; you can make this from notched plastic, linoleum or stiff card, or use a cheap metal comb if you don't mind the grain being very parallel — you can also use this comb for separating brush bristles. A notched cork is useful for knots, a wide, soft-bristled paint brush for mottling, and a fine-pointed artists' brush for touching in individual lines of grain. Also necessary are clean rags, mineral spirits and, preferably, a sponge.

Professional decorators use a veritable army of brushes for graining, the vast majority of which you can manage without, if you use those suggested above; but there are four of greater importance. It is a good idea to get two of them if you can, as they will make the work far easier and give it a more sophisticated finish. One is a flogger , which is used to beat the surface and "fizzle" the grain; that is, to give it kinks. A mottler is another, which mottles and gives the surface highlights. A badger softener is used to blend and soften effects of all types; this is a very old type of brush that comes in a great variety of sizes and was originally made of badger hair. Fortunately, the protection of badgers in some countries has meant that these excellent tools are now made of other materials that are very nearly as good; although this does make the term "badger softener" rather mysterious to many people. Of

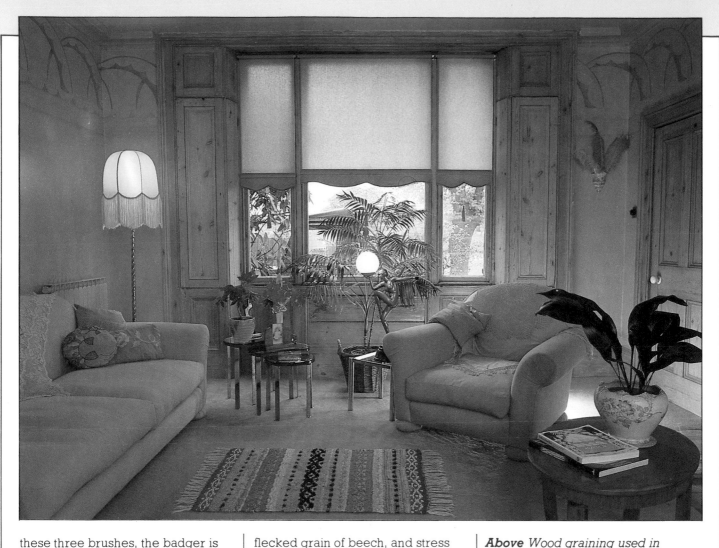

these three brushes, the badger is undoubtedly the most useful and versatile and if you have to choose one of the three, choose that one. It can basically be used for all three effects; flogging by using it side on, mottling by using it vertically or in a pencil-shading motion, and softening by stroking; you can even drag with it if you keep it dry. The fourth decorators' brush is a fine sable writer a long, fine-pointed brush used by sign-writers and sometimes known as a pencil because of its fine point. Sable is pricy, but there are nylon substitutes available. These purport to be as good but they aren't — they have an unpleasant habit of fanning out and going hard. The sable writer is really very useful; it is about the same price as other artists' brushes of the same size and is definitely a recommended investment.

■ **Application** Bear in mind that you are basically creating the essence of wood in this effect, rather than making an exact representation of a real, specific wood. Choose the elements you like most about any particular type, such as the light, flowing grain of pine or the close,

flecked grain of beech, and stress those. Always remember to keep a balance between the absolutely regular pattern — which will look unnatural and is the great, lifeless weakness of wood-patterned wallpapers — and the completely random design, which will be just as unrealistic and also unpleasantly chaotic.

Method I If you apply a glaze tinted darker than the base color, you can comb it, but waver the comb as you go so that the teeth leave fine, undulating bands of the base color while the grain stands out in a darker tone against them. This may be quite sufficient for your taste, but if you want to go further you can touch up these combed lines with a dilute solution of 1:2 paint to mineral spirits. If you seek a more subtle grain, use a graining or dragging brush. This is applied much in the manner of the dragging technique of broken color, in this case to remove wet glaze. The result is a fine, fluffy grain if the drag brush is well dried. A denser, heavier effect comes from a cut-down brush but if you use a comb to separate out the bristles evenly, from time to time, an excessive weight of

Above *Wood graining used in conjunction with stenciling. The arching patterns of the stenciling balance the regular angularity of the wood, and the wood gives a visual anchor and stability to the stencil.*

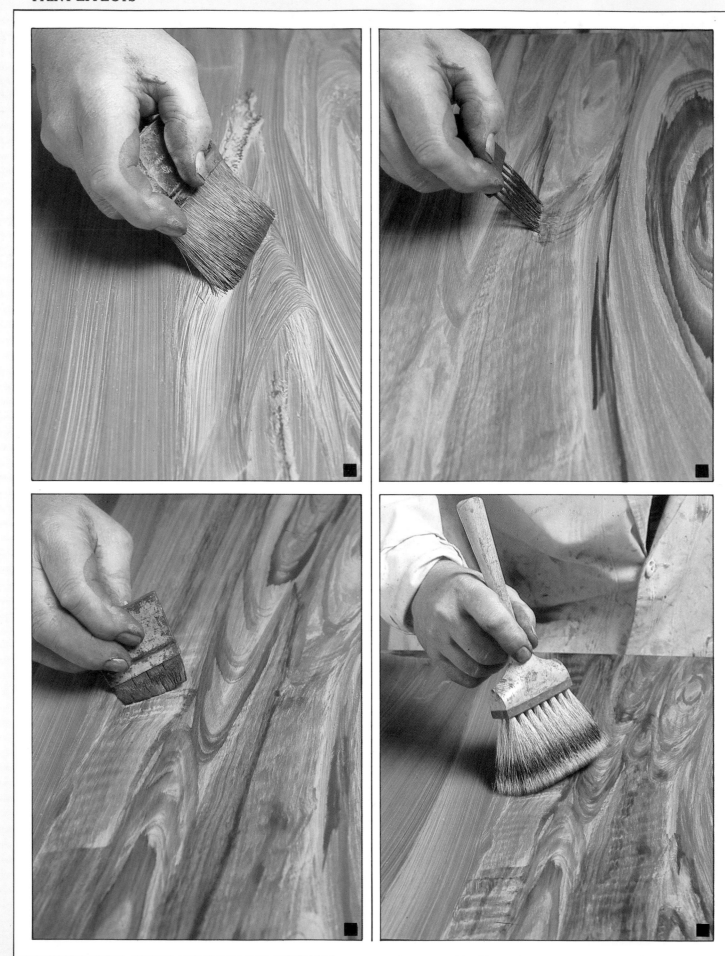

stroke is easily avoidable. If you beat the graining glaze with a flogger or dusting brush substitute, you will get fine openings in the glaze like pores. Hold the brush horizontally to the surface and beat lightly and rapidly as if beating a fragile rug. If you strike along the line of the grain and then across, you will get a closely textured, fibrous quality. Alternatively, you can hold the brush perpendicular to the surface like a stippler, or push it backward or forward over the grain to achieve a softening of the grain markings. Thirdly, you can apply a glaze of clear shellac over either a painted grain or a textured glaze, and then finely spatter color over the shellac surface, softening it immediately afterward by whisking it with the tip of a soft, dry brush — such as a badger — in the same direction as the grain.

These are all textural methods. You may find any of them effective but none are indispensable. You can texture a glaze, let it dry and then paint grain on with a dragging brush, using the bristles to put paint on the glaze, rather than to remove it from the base coat. This is part of Method II.

Method II Using a brush to put on colored glaze rather than to remove it allows greater versatility in the effect. The movement is more fluid and the grain can be varied more easily in width and intensity. In one movement — if possible — draw the brush down the surface, undulating it as you go; this is much easier than formal dragging, as you don't have to worry about keeping the stroke straight. Where you feel a knot should be, turn the brush at a curving tilt so that the spread of the bristles becomes narrower, and then curve it back again as you straighten out after completing the bulge. That will give you a tightening of the grain around the knot, which then visibly opens up again as the grain flows on beyond it. Knots are best applied with a notched cork or a torn, screwed-up piece of blotting paper: coat the end of the cork or paper with paint and press it flat against the surface, then withdraw it. A second time, on another spot, twist the cork or paper slightly; another time, only half-coat the end or rotate and/or run it slightly downward about 1in (2.5cm) in a short, sharp action to create a long knot. Another method is to core the bristles of a stenciling brush and then rotate the brush on the surface, but the effect is less

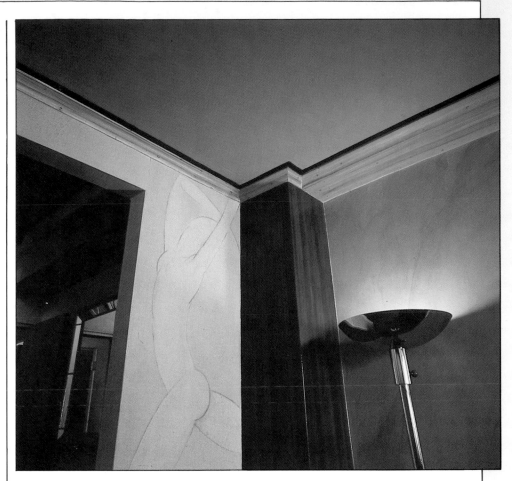

convincing than that produced by a notched cork or blotting paper.

Wood frequently possesses a mottled, silky quality, and the most straightforward way to evoke this is to load a cloth or chamois leather with mineral spirits (or water, if you are using a water-based paint) and dab or roll the surface with it, usually between widely spaced grains so that it frays their edges. Alternatively, dab mineral spirits on the bristles of a dry brush and draw them lightly across the grain, rocking the brush from side to side.

Method III This has more in common with marbling than with dragging and combing, and its finish is ultimately far more sophisticated than the preceding methods, with perhaps the exception of very finely executed beer graining. The materials are a large painters' brush for the application of the base coat, three hues of artists' oil color, depending on the tone of the wood — for example, burnt umber, lampblack and Indian red for rosewood — mineral spirits, linseed oil, rags and three artists' brushes, preferably a ½in (1.2cm) bristle flat, a sable from ⅛in (0.3cm) to ¼in (0.6cm), a sable writer and a badger or feather.

The base coat should be flat-oil or undercoat, tinted with artists' oils to the required tone. The graining itself is executed with three sizes of artists' brushes or sable writers; the oil color is diluted 2:1 or 3:1 paint to mineral spirits or, if the surface is such that drying time is not a problem, then 1:1 or 2:1 oil color to linseed oil. The surface can then be brushed overall with a 2:1 mixture of linseed oil to mineral spirits, or with the faster-drying preparation of flatting oil — 1:6 parts boiled linseed oil to mineral spirits. The filaments of the grain can then be brushed or floated onto this surface, being softened into it where desired with a feather or badger softener. Or, conversely, the grain can be laid on with the small brushes, and the spaces between them softened or blended where desired by brushing their edges with a 2:1 linseed oil to mineral spirits, or flatting oil, mixture. These methods produce a smoother surface and a great sense of depth and translucency, such as can be seen in polished woods such as rosewood, mahogany, cherry and satinwood. Of course, such techniques take longer to dry than the preceding ones, but their finish is vastly superior.

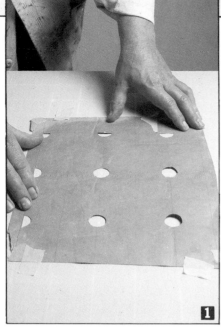

1

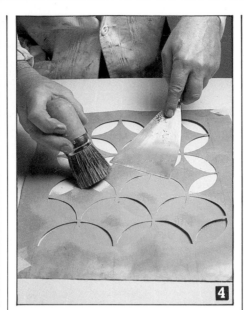

4

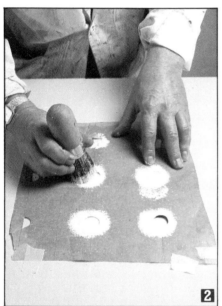

2

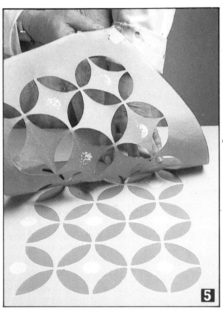

5

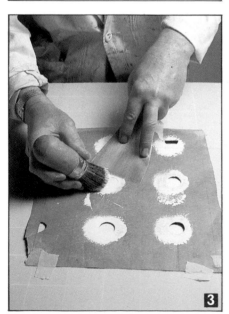

3

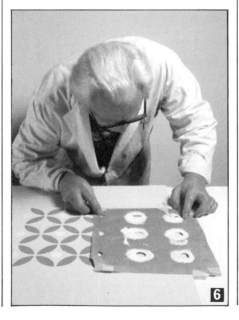

6

STENCILING

Stenciling, like marbling and wood graining, is a technique that dates from antiquity. There are examples of it on surfaces from walls to shields, domestic houses to painted tombs. Its simplicity is equalled by its charm, and, on occasion, by its beauty, because it can be applied with great delicacy as well as with the more familiar bold effect. It can also be executed on almost any painted surface — provided that it is clean and sound — and many unpainted ones, including wood and metal. Its popularity has waned in Europe until recent years, due largely to the use of wallpapers and, in part, to its rather vulgar and heavy-handed use in the late Victorian period in England where it was often misapplied in a banal, grandiose manner without the delicacy and fineness of earlier periods.

In Europe, stenciling has tended to be more of an industrial process for much of this century, appearing on signs, aircraft and roads rather than in domestic interiors; sculptors have used it to the full on painted structures for its strength and crispness, but interior designers have only recently warmed to it, largely inspired by the work of one particular individual, Lyn Le Grice.

In America, it was better used from the start, and indeed the technique was largely preserved by American settlers who turned it to unpretentious good use as a form of decoration on plaster, floors and

furniture in clapboard houses. As a result, it achieved status and has become part of American folk-art and culture.

On pale walls, either in a frieze pattern or as a pattern distributed from the corners spreading outward into the room, there is no real color limitation, provided that the colors do not become too various and loud or the pattern confused and disjointed. Very muted color can be particularly beautiful — on off-white walls, gray or blue-gray and beige patterning can make the wall look like a big, damasked cloth; or with a simple pattern of strong regularity you can use color of almost Etruscan intensity — such as vibrant Indian red or deep, vivid blue. On woodwork, if it is clear and sealed, patterning of muted, warm earth colors and olives looks very well, giving that variety within unity that one sees in high quality marquetry. Woodwork that is painted overall can take areas of very intense color; provided that it's not overdone, it can be extremely effective.

As with most other decorative effects, it is always better to err on the side of restraint in stenciling; you can always strengthen what you've done, but it's very hard work toning it all down again, let alone taking out whole sections of a design. Strong patterning works well on floors, where you can "paint your own rug" if you wish; you can, in fact, use stenciling anywhere in any room — provided that you protect it with varnish. With this technique, you also have complete control over the design. You can choose one from any source; you will simply need to scale it up by tracing it, then drawing a grid over the tracing and scaling up the squares. It is possible to buy ready-cut stencils with modern or traditional designs, if you wish. It is then easy and inexpensive to test your designs and plans, either by using colored paper cut to the pattern and stuck to a wall or other surface with masking tape, or by painting the pattern onto a piece of lining paper and pinning that to the surface to gauge the effect. You need apply not one drop of paint until you've got the whole thing absolutely right, which is a great luxury. Stenciling is a process where the preparation takes longer than the application. However, this is no drawback as half the creative enjoyment of the process lies in the design and preparation of the stencils themselves.

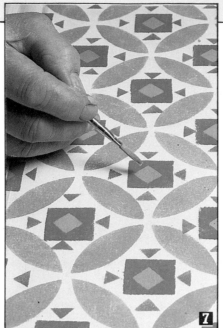

7

Stenciling sequence

1 *Fix the stencil-board firmly to the surface to be painted.*
2 *Apply paint vertically with a flat-ended stencil brush, using a pouncing action.*
3 *Press the stencil-board flat if necessary to stop paint getting under the edges.*
4 *When the first stage of the pattern is dry, apply the next.*
5 *Lift the stencils vertically, peeling backward, never sideways.*
6 *A basic shape carefully aligned on a grid can alternate various orders of pattern.*
7 *This pattern can be touched up using an artists' brush or sign writers' "pencil".*
8 *This basic stencil can be used in a series of variations.*

8

■ **Cutting stencils** Stencils can be made from a choice of two materials. You can either use clear acetate or oiled stencil-board. Both have their advantages and both require slightly different methods of preparation. If you use acetate for stencils, you will need a special pen to draw on it, a technical pen; for oiled board, a felt-tip pen. A scalpel is necessary in both cases, and a cutting surface — hardboard, plywood, chipboard or, best of all, glass. If you are going to copy a design, you will need tracing paper, and with oiled board you will also need carbon paper and a 5H pencil or fine-gauge knitting needle. In both cases, you need a straight-edge, preferably a metal ruler, and masking tape.

Acetate Using clear acetate for stencils bypasses the need for tracing paper. You can place the acetate directly over the design and then trace the design straight onto the acetate with a technical pen. This is particularly useful if you are going to work in a variety of colors and need a separate stencil for each color area. Acetate is most effectively cut on glass, because previous score marks on a cutting board can jolt or turn the blade, and acetate can split if cut suddenly at an awkward angle as a result of snagging the blade like this. Fix the acetate in position on the glass with masking tape to stop it sliding, and protect the edges of the glass with tape to prevent it chipping or cutting you. Hold the knife firmly and cut smoothly and steadily. Cut toward yourself, but *never* place your hand in the path of the advancing knife blade; a scalpel, even moving slowly, will almost always make a deep wound. When cutting curves, turn the board steadily, not your knife hand. Cut small, detailed areas first, but don't try punching them out on glass. Any rough edges can be smoothed with fine abrasive paper. The drawback of acetate is that it has a habit of curling up as you cut it, owing to the heat of your hand, and it can crack and split on tight curves. In general, though, it is rather easier to cut than oiled board.

Oiled stencil-board This has the advantage of being a lot cheaper than acetate, and thicker; it is possible to bevel the edges of the board as you cut it to ensure that paint doesn't seep beneath the rim when you apply the stencil. When cutting the stencil from board, copy the chosen design with a fine felt-tip pen onto tracing paper, then

transfer it onto the board, using the point of a fine-gauge knitting needle or hard 3H or 5H pencil and carbon paper. Leave a margin of at least 1 – 2½ in (2.5 – 6.2cm) around the design, to ensure that the stencil isn't floppy. As with acetate, fix the board to the cutting surface with tape and cut it in the same manner (preferably on glass). Lining up board stencils is a little trickier than it is with acetate. The best way is to cut them all first and then align them exactly one on top of the other, trimming all the boards to the same size. Also, make small holes in the corners so that you can put a small pencil mark through them onto the wall in order to guide the position of the stencils in the sequence.

Make sure when you cut a motif

Above *Subtle and graceful stenciling, applicable to many interiors, adds quiet panache to an upright piano.*

Above right *An elaborate stencil on a floor surface, abuting marble. A somewhat eccentric mixture but the coloring is well balanced.*

Lower right *A stenciled chest of strong, bold design is excellently in keeping with the chunky, four-square stencil of the stripped and varnished floor, which has the eye-catching simplicity and panache of good industrial code designs.*

that you always cut it from one piece of board; don't continue it into another piece as the join will always show when you paint in the pattern. Never cut too near the edge of the stencil boards or they won't be rigid enough to use and may even break up. Also, make sure that if your design goes around a corner, you cut two stencils that allow for this; don't bend a stencil around the corner — it may work once but the second time you may get seepage of paint, or worse.

■ **Paint and brushes** You can stencil on practically any type of paintwork, provided that it is clean and in good condition. Gloss paint has less key than the other types and so is marginally less suitable, but you can put a matt varnish over it if you don't care about losing the shine. Natural wood needs two thinned coats of matt or satin varnish to seal it, but any other paint surface will take stenciling, provided that it is level.

Similarly, there is a wide choice of stenciling paint. If you are in a hurry there are sign-writers' colors, thinned with matt varnish or mineral spirits; artists' acrylic colors, thinned if necessary with acrylic medium or water; and latex paint, tinted with artists' acrylics or universal stainers. These are all very quick-drying. For woodwork, flat oil-based paint, undercoat or egg-shell, tinted with artists' oils and thinned with mineral spirits, are all very suitable but rather slow-drying, though they can be speeded up with a drying agent. In all cases, never make the paint thinner than half and half because if it is watery it will run under the stencil and mar the pattern.

Somewhat surprisingly, perhaps, sprays are not very good for stenciling. If you do use sprays, the template must be held down very firmly around the area, for sprayed paint has a marked tendency to seep. If you obey the manufacturers' instructions and deliver the spray horizontally, not at an angle, you lessen the risk of seepage but it can still happen. Sprays are also far more expensive than other mediums, and over an area as small as a stencil it's difficult to get solid, even coverage without sweeping back and forth over the area; this means that you get either seepage or, if you hold the spray close to the surface for denser coverage, drizzling. If you hold the spray well back and don't go heavily into the edges of the motif, then you get a fuzzy, fluffy shape instead of sharp definition. In some

Preparing a stencil

1 Trace the design onto the stencil-board. If you don't wish to use carbon paper, pencil the design on both sides of the tracing paper and go over it to transfer the graphite on the back of the paper onto the stencil-board.

2 These faint lines can be gone over afresh with a sharp pencil.

3 You can trace a design directly onto clear acetate and cut it immediately; on the other hand, acetate cracks easily when you cut it and it is floppy when held vertically against a wall; this allows paint to creep under the edges.

4 When painting, pounce the flat-ended brush vertically up and down, and try not to overload it.

circumstances that might be acceptable but not usually; it gives the appearance of a faded decal. Also, you don't save time because you have to go back and forth gradually over the same region, which takes a good deal longer than one good application with a stenciling brush.

Stenciling brushes closely resemble shaving brushes with the bristles chopped off short and square. They are stubby and squat and sometimes known as 'pounce brushes' after their method of

application — an up-and-down pouncing or dabbing stroke. They aren't very expensive and there's no need to make a substitute — cutting down another brush isn't necessary and won't be any cheaper. They come in various sizes, with the smallest ones resembling fitches; some are actually called fitches. Fitches are round in section, flat-ended and used for very detailed stenciling. All of these brushes leave an orange-peel texture on the surface, a slightly grainy appearance. If you really don't

want this texture, use a sponge, an ordinary decorating brush, a folded rag or paint pad. An ordinary brush carries the risk of coating slightly under the edge of the motif. Whatever tool you use, the secret is not to overload it. Test on a piece of paper with a test stencil to gauge the correct loading.

Other tools You will also need a hardboard or, preferably, glass panel as a palette for the paint, as it is not advisable to put paint straight on the brush from a container; clean rags, appropriate solvent, masking

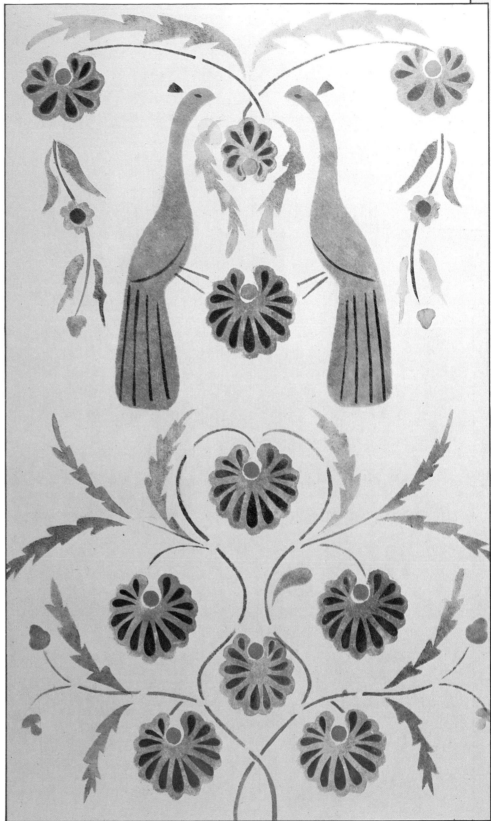

tape, spirit-level, a straight-edge, chalk, T-square and plumb-line.

■ **Application** First, you must mark the position of the stencils on the wall. If your design follows a frieze format — that is, a series of patterns following each other along a regular plane, usually at eye level or above — never take your measurements for verticals and horizontals from the walls or ceiling; they are usually out of true. Draw all horizontal lines in chalk using a spirit-level, and take verticals from this horizontal using a T-square. Then check these with a plumb-line. Next, mark the position of each stencil on the wall with a pencil, using corresponding notches on the stencil to line it up; that is, the pencil mark on the wall should fit into the notch on the stencil.

If you have a freer overall pattern on a floor, or a rug style, then square off the floor with chalk lines and mark the position of each stencil as before. If you have a border around the pattern, it should be

Above left Cut a different stencil for each color in complicated designs.

Left To imply age, soften the color by adding a transparent glaze mixed with a little white pigment to the color.

Above Mellowed coloring improves many simple, naive folk designs. A coat of tinted varnish grays the greens, makes reds pink and turns yellows a gentle amber.

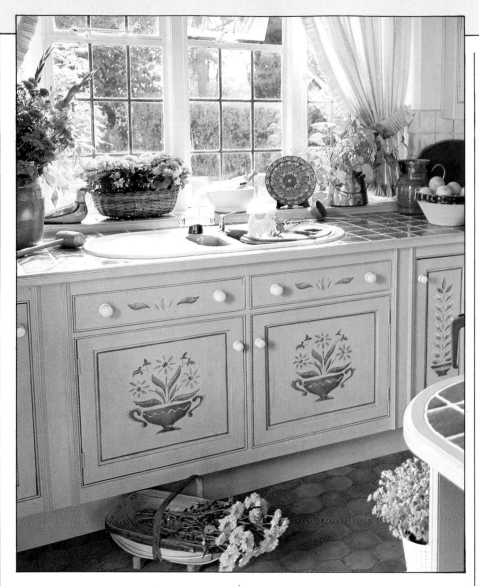

equidistant from the wall all round. Lay out the border by drawing parallel chalk tracks; the distance between the lines should be the width of the stencil templates. Of course, it could be that your room really is very off-square; the best thing to do in that case is to draw a right angle where your border chalk lines meet at the corner, and then when you see just how crooked the room really is, draw the border so that it is somewhere between the two. For example, if the corner of the room is about 41°, and the true corner angle 45°, draw your border at about 43°. Also remember that you can't take motifs round a corner on a flat floor in the same manner as you would on the vertical corner of two walls. You must divide the length of your border by the number of motifs you have and space them out evenly so you don't get one motif colliding with another on the corner turn. Mark the central point of each motif on the stencil template and the tracks.

When you come to apply the paint, fix the stencil firmly in position with masking tape. Pour out a small amount of paint onto the palette, dip the face of the brush once into it, and then stamp it firmly out on a clean area of the palette or, preferably, another testing surface, to distribute the paint evenly and avoid any heavy or unequal loading. Then, working from the edge of the motif inward to the center, dab the thinly coated brush straight onto the surface. Rock it back and forth slightly to transfer color evenly, but don't smear it across the surface or you'll risk carrying paint under the stencil. When the motif has been filled in, let the paint set for about 30 seconds and then lift the stencil off carefully and *vertically* and transfer it to the next position. If the board is going to overlap adjacent stencils, apply them alternately to avoid smudging the paint.

If you are working in several colors, always allow one color to dry before commencing the next. Don't worry about any build-up of paint on the edges of the stencil as this just means you are applying the paint correctly; but clean it off at intervals by wiping it with a sponge or rag steeped in the appropriate solvent, in case it begins to get badly clogged. When you've finished, clean the stencils and brushes with the same solvent and store the stencils flat. Separate them with tissue paper or baking foil; it's a good idea to keep used stencils because if ever you wish to repeat the pattern it will save you a good deal of time and work. It also means that you can retouch the surfaces at any time, if necessary; stencil work can be retouched with relative ease. Stored properly, stencils last a lifetime.

Remove any pencil and chalk marks from walls with a clean eraser. This is important as you will have to varnish stenciling; any graphite dots will show up under varnish like little hazy flies because varnish tends to disperse light through its surface and so exaggerate blemishes that would otherwise be unnoticeable. Leave the paint to dry for at least a day — two days for oil-based paints — before varnishing. Two coats of matt or satin-finish varnish are a good idea on walls, and on woodwork and floors they are absolutely essential. Floors look best with satin or matt over gloss varnish to give them a soft sheen, and need at least three coats, preferably five.